Kalamkari and Traditional Design Heritage of India

Shakuntala Ramani

wisdom
tree

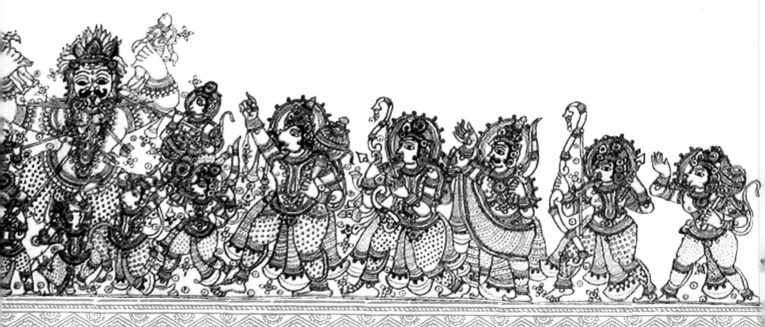

ISBN 81-8328-082-X

Published by
Wisdom Tree
4779/23 Ansari Road, Darya Ganj
New Delhi-110002
Ph.: 23247966/67/68

Published by Shobit Arya for Wisdom Tree;
copy edited by Manju Gupta;
designed by Kamal P. Jammual;
printed at Print Perfect, New Delhi -110064

Contents

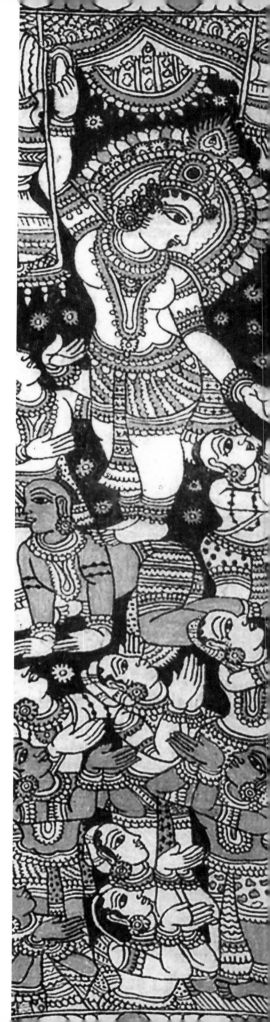

Preface

A research unit for reviving the use of vegetable dyes in present-day fabrics was established at the Craft Centre of Kalakshetra in the year 1979. The project was initiated by Kamaladevi Chattopadhyay, the doyen of Indian handicrafts and Rukmini Devi Arundale, founder president of Kalakshetra. The research programme was started with the establishment of a Kalamkari unit in our premises.

Kalamkari is an ancient Indian textile tradition in which designs are fully hand-drawn or block printed using vegetable dyes. Fabric samples have been found during excavations at Mohenjodaro dating back to 2600 BC to 1700 BC. Similar fabrics were also found in a tomb at Al Fustat near Cairo proving that it was a prized commodity of trade in the ancient world.

This beautiful art however, had all but vanished in the country of its origin. The term Kalamkari was used in the Indian marketplace to describe a particular type of block print often produced with chemical dyes. Traditional Kalamkari centres had disappeared and craftsmen who knew the ancient techniques were a mere handful who jealously guarded their knowledge to preserve their monopoly.

As head of operations, I had to travel widely to understand and unearth the secrets of this craft which was nearing extinction. A study of

ancient Kalamkari textiles in museums and private art collections revealed the inner strength of this art form. It was fascinating to see very old textile pieces dating back to the 17th and 18th centuries, tattered and brittle with age but still retaining their original colours produced with vegetable dyes. It was obvious that age-old practices and traditional techniques, even though unscientific, had stood the test of time. Kalamkari designs pertaining to different periods in history presented a pictorial record of the changing face of society through the ages.

As the study progressed, spiralling back into the mists of time, the magnificence of this art form stood revealed in all its glory touching many areas of human endeavour, just like the cosmic figure (Viswaroopam) of Sri Krishna revealing the whole of creation within his body (allusion explained on p. 6).

In writing this book, I have attempted to explain the early origins of this art form and subsequent transformations though the ages, which makes it so rich in content and imagery transforming it from a mere textile design to an art form, which reveals the very soul of Indian culture.

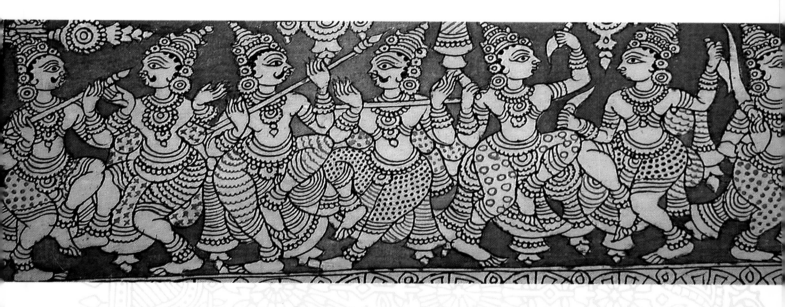

Viswaroopam

The scene is the battlefield of Kurukshetra. Armies of the Kauravas and Pandavas are lined up, facing each other, to do battle. Brother would kill brother, and kinsmen in their hundreds were going to be killed. Arjuna, overcome with sadness and revulsion, is unable to lift his bow against his elders and gurus like Dronacharya, Bhishma and others.

It is then that Sri Krishna expounds on the *Gita*, removing Arjuna's *maya* (illusion) and explaining to him the nature of the soul, which never dies. It is only the outer physical form, which is discarded like old clothing. "So cast aside your doubts," he says. "Do what has to be done and perform your duty as a warrior." The argument of Arjuna against destruction of life, is answered by the doctrine of indestructibility of the spirit behind all life. It also points to his *karma* (duty) as a warrior in a complex human situation.

The word *karma* is connected with the Sanskrit word *kriya* or action and is similar to the English word 'create'. *Karma,* action or creation, is linked with *jnana,* contemplation, in the *Gita,* according to which external action is linked to the inner spiritual vision.

Indian philosophy talks of three types of vision: one is the ordinary vision of the human eye, *mamsa chakshu;* next is intellectual perception or *divya chakshu;* and the last is the inner vision or *pragna chakshu,* which arises out of contemplation. Sri Krishna confers the gift of *divya chakshu* upon Arjuna, who is then able to see the cosmic figure,

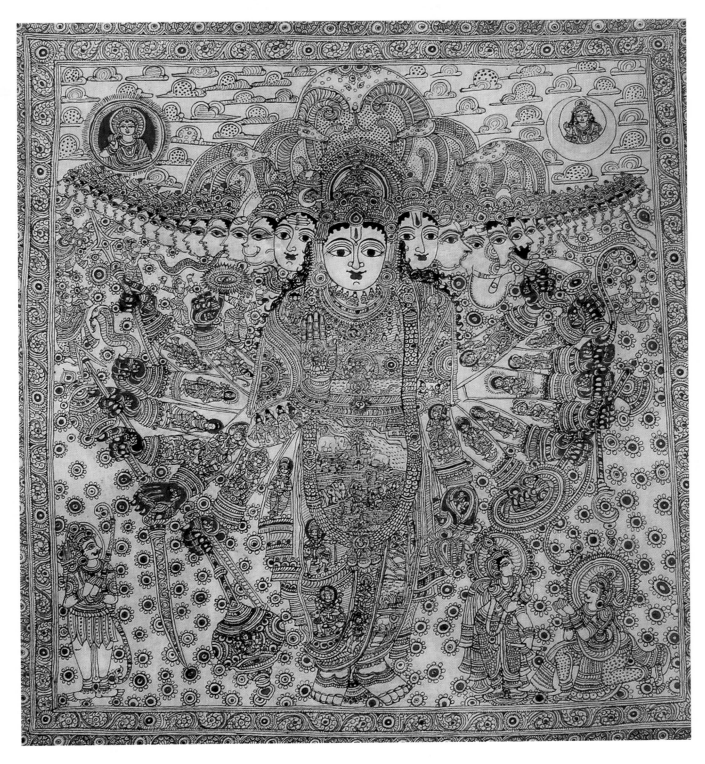

Plate 1: 'Viswaroopam' — Kalamkari tapestry painted with vegetable dyes depicts the cosmic figure of Sri Krishna revealing the entire universe within his Divine form. In the bottom right-hand corner he is shown in his human frame expounding the *Gita* to Arjuna kneeling before him. Tapestry painted by C. Mohan, Kalamkari artist (author's collection).

'Viswaroopam', of the Lord. The human form of Krishna grows and expands, filling the entire universe, and in this form, Arjuna sees the entire pantheon of gods and countless creatures being created, taking birth and dying, in an endless cycle of life and death *(Plate 1)*.

The meaning of art is similarly a mystic experience for which one needs *divya chakshu,* the inner perception. For understanding Indian traditional art, or for that matter, any art form, one needs Divine vision to understand the message of the artist. Beyond the outer image is the inner meaning, which can be perceived and shared both by the artist and the viewer. It is this vision, the shared experience, that reveals the Soul of Art.

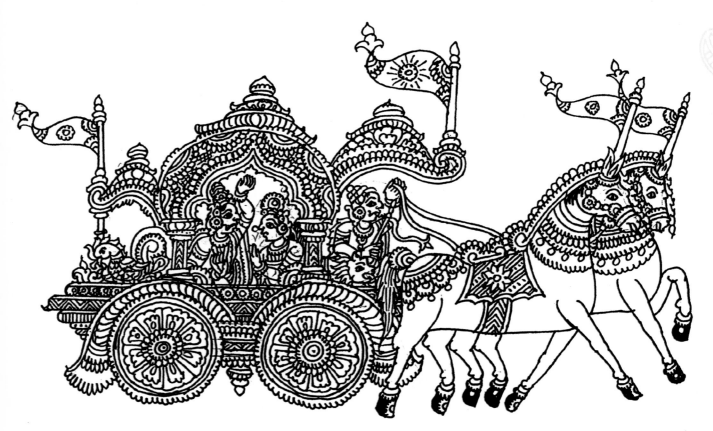

GITOPA DESAM: Kalamkari line drawing.

Introduction

The Indian textile tradition is very ancient, spanning a period of over 3,000 years. The fabulous silks and brocades of India, which dazzled the world were greatly prized and sought after by the rich people, but it was the simple cotton Kalamkari fabric, which had wider impact and revolutionised garment trade in the 18th and 19th centuries. Cotton was indigenous to India, and the skill of the Indian weaver produced fabrics so fine and light that they were poetically described as *shabnam* (morning dew) and *baft hawa* (woven air). In those days, dyes were obtained only from natural sources, and Western dyers and printers were unable to produce colour-fast fabrics from such colours. The Kalamkari fabrics of India, with jewel bright colours, printed and painted in fascinating and intricate designs caught the fancy of women in England and France and became the fashion for daily wear. The whole world went crazy over these cotton fabrics. Dubbed as 'chintz' by the textile trade, the import of Indian textiles reached such enormous proportions that England, France and other Western nations had to prohibit import of Indian fabrics, by law. This was the age when the Kalamkari tradition became widely known. Even now, such textiles are identified by their soft vegetable dye prints, which reveal a strong Iranian and British influence. Not much is known of the origins of this textile tradition, its earlier form as a temple art, and the singular role it played in the social history of India.

Like all other arts and crafts of India, the Kalamkari tradition also has a strong spiritual base. It blossomed in the environs of the Hindu temple, as a religious tapestry, which supplemented mural paintings around the sanctum and corridors of the temple. Wandering minstrels painted mythological figures on cloth and carried these tapestries from place to place, singing and spreading the word of God. It was part of a flourishing popular cult, which had strong roots in the village life of India. It is this vast rural base, which makes this fabric more representative of grassroot Indian culture than the lifestyle of the Rajas and Sultans with their penchant for heavily embroidered silks and brocades.

The study of this textile design tradition brings to light the evolution and change that took place in the lives of the Indian people. Its origin as a religious tapestry, the folk beliefs that shaped it, the transformation under Muslim rule as a secular craft and finally as a flourishing item of trade under the British, when international market demands left its impress on the Indian base fabric, making it a fabric of true historical value.

Not merely a textile traditon, the rich and varied design element which carries the impress of different cultures makes it a fascinating study of the changing face of Indian society. It is this little known aspect of the Kalamkari tradition that is brought into focus in these pages.

The Kalamkari tradition of painting on cloth with vegetable dyes is unique in many respects. It grew and gained importance as a visual medium to support the *chitrakatha* tradition, which was a part of Hindu folk religion. It played a significant role in propagating the tenets of the well-loved epics, the *Ramayana,* the *Mahabharata* and other Hindu *shastras.*

The *chitrakatha* tradition was widespread and different regions in India developed this art in their own fashion to spread the message of God. Better known among these are the Madhubani paintings of Bihar, Yama Pata paintings of Bengal, Pabuji-ki-phad of Rajasthan, the Patachitras of Orissa, Mata-ni-pachedi of Gujarat, and Nathdwara Picchavai paintings associated with the Srinathji temple in Udaipur.

Each tradition is linked to a central deity or thought. Nathdwara paintings expound upon the greatness of Sri Krishna, the deity of that temple. Similarly, the Patachitras of Orissa illustrate the story of the presiding deity of Puri, Sri Jagannath with his sister Subhadhra and brother Balabhadra. Kalighat paintings are based on the awe-inspiring figure of Goddess Kali, the popular deity of the people of Bengal. These pictures are full of fire and brimstone, depicting *patalaloka* (hell) to warn sinners against straying from the straight and narrow path of rectitude. Pabuji of Rajasthan, on the other hand, is a military figure, a tribal hero, deified by the Rabari caste — a nomadic tribe who carry these painted scrolls during their wanderings, singing his glories in the marketplace. Madhubani painting of Bihar is a domestic art produced by householders to celebrate social events like marriage, childbirth or the sacred thread ceremony. The central figure of all Mata-ni-pachedi paintings of Gujarat is Durga Mata, who is shown in various forms. Produced by the Vaghari caste of

Ahmedabad, these pictures are made as votive offerings to the temple with prescribed rituals that regulate both the production and ceremonial gifting of these temple-cloths. In all these forms of painting, there is generally only one central figure and theme.

The Kalamkari tradition, on the other hand, differs from all these, imparting a larger dimension and diversity to pictorial exposition of mythological stories. Even though it developed as part of temple ritual, it is more broadbased, and has a vastness and richness of presentation unequalled by other art forms of this genre. The function of the temple Kalamkaris is narrative in character. The rich treasury of Hindu mythology provides the art with a repertoire of themes and well-loved legends. The Kalamkari canvas is thus vast and varied. Some paintings describe a single episode and some an entire epic like the *Sampoorna Ramayana*. Even while illustrating single episodes, the Kalamkari paintings vibrate with life and are full of colour and detail, making a powerful impact on the viewer.

A distinctive aspect of Kalamkari is the versatile use of vegetable colours by the artist. While other religious paintings are produced in the tempera technique on cloth or paper, stiffened with emulsions and binders, Kalamkari paintings on cloth are produced by application of dyes extracted from natural sources like roots, leaves, flowers and fruits. Kalamkari craftsman have, over the centuries, perfected the technique of using vegetable dyes, through constant use and application. This ancient lore, handed down by word of mouth, through many generations of craftsmen was a well-guarded secret, which excited the curiosity of people all over the world, and concerted efforts were made during the medieval period to unearth the secrets of this craft.

Plate 4: Mural from Tiruppudaimarudur temple illustrating a significant event in the history of the Tamil people. Young Tirugnana Sambandar, a Saivite saint enters Madurai (*credit*: Justice Ratnavel Pandian).

social life of the people depicting everyday incidents was painted, portraying the ambience of the period (*Plates 2 and 3*).

In the Shiva temple at Tiruppudaimarudur, in Tirunelveli district, for example, there are paintings which dwell on the stories of Tamil *nayanmars* (Saivite bards) of that period. A significant landmark in the history of Tamil culture, during the late 7th century, was the revival of Saivism and Vaishnavism in the face of increased conversions of people to Buddhism and Jainism. Tamil Nadu was tolerant of other religions, but when forms of worship started changing and worship in temples began to wane, intolerance and resistance crept in. Votaries of Jainism and Hinduism became rival combatants, each determined to overcome the other.

Jain scholars who enriched Tamil literature were respected by the people. Some of them, like Ilango Adigal, were authors of great Tamil classics. Some Jain scholars even compiled Tamil lexicons. Many Jain saints were close to the rulers of the period and took part in the laying down of religious policy, leading to the neglect of some well-known Hindu places of worship. This gave rise to religious rivalry and emergence of a strong movement to revive Hindu Vedic religion by Saivite and Vaishnavite saints. Of the 63 *nayanmars* of the Saivite hagiology, the four most distinguished ones were Appar, Sambandar, Sunderar and Manickka Vachagar, often referred to as *Nalvar* (The Quartet). They composed devotional hymns which they sang as they travelled from place to place, visiting every Hindu shrine in the region. These simple songs captured the imagination of the people and constitute the earliest corpus of South Indian

musical compositions. Endowments were made by the kings for regular recital of these songs in the temples with proper instrumental accompaniments like the flute, *tambura* and drum. The singing of Thevaram hymns as part of worship in the temples continues to this day, showing the firm hold that Tamil saints had over the popular ethos.

Mural paintings in Tiruppudaimarudur temple show the young saint, Tirugnana Sambandar, being carried in a palanquin to the palace of the Pandyan king, at Madurai, who got converted to Jainism (*Plate 4*). Sambandar performs a miracle by curing him of an illness, and the king returns to the Hindu fold. Later, to establish the tenets of Saivite religion, Sambandar challenges the king's Jain preceptors to a debate on their respective religions. He is shown performing a miracle at the temple. Each contestant is made to inscribe his religious belief and philosophy on a palm leaf before consigning it to the flames in a sacrificial fire. Only the palm

leaf that contained the true faith was said to be accepted by God if it remained unscathed. In this illustration, we see the boy-saint, Sambandar, with the king behind him and the Jain priests, standing opposite, consigning their palm leaf scrolls into the fire (*Plate 5*). In this contest, Sambandar's scroll remains unburnt, thus revealing his spiritual supremacy and that of the Saivite religion.

Tirugnana Sambandar was a boy prodigy who started composing songs at the tender age of three years. It is said that he was suckled by Goddess Parvati herself when he sat crying out of hunger near the temple tank at Tiruvarur. His knowledge of the *Shastras* without schooling and capacity to compose songs even as a child are attributed to this Divine grace. Sambandar died young and in a short span of 16 years, he composed more that 300 songs and visited every Hindu

Plate 5: Tirugnana Sambandar challenges Jain priests and converts the king to the Saivite faith — Tiruppudaimarudur temple mural (*credit*: Justice Ratnavel Pandian).

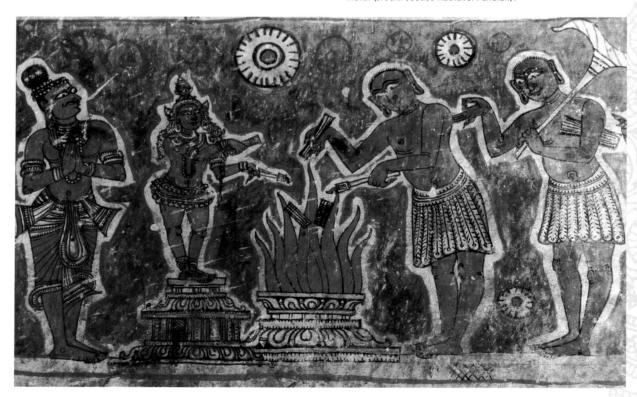

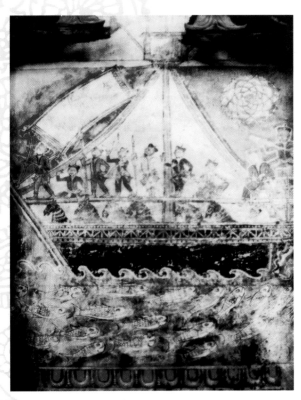

Plate 6: Arab horses being brought by ship to Tamil Nadu. Naik mural painting in the Tiruppudaimarudur temple (*credit*: Justice Ratnavel Pandian).

are shown in conical headgear, typical of the Naik period while the soldiers wear ordinary turbans. Marching armies with soldiers on foot and on horseback, palanquins carrying nobles, traders selling jewellery — all are shown in the profusion of paintings adorning the walls. In the Meenakshi temple at Madurai, the wedding scene of Shiva and Goddess Meenakshi is painted on the southern wall of the sanctum. In this colourful mural, the ruling Naik prince and his queen are also shown with folded hands on either corners of the painting (*Plate 7*).

The mural tradition of Hindu temples shows that Indian art, though largely religious, had secular manifestations which are equally important and fascinating. The function of temple art was to propagate the tenets of Hindu religion, its mythology and philosophy. Since the religion itself was broadbased, the canvas of the mural paintings was vast and varied. In the absence of photography and other electronic devices with which we are so familiar today, we can understand the compulsions that led to the profusion of pictures, both religious and secular. Their aim was to record the life of a bygone era faithfully. Through this visual medium, the captive audience of worshippers, day in and day out, were informed and elevated in various ways.

References to painting are numerous in Indian literature, which had a wider and more popular base than other arts, and was not restricted to craftsmen alone. Rulers, on their part, encouraged a love for this art by constructing *chitrashalas,* picture-palaces, in public places, apart from the temples. The king's palace as also the residential houses of noblemen were decorated with paintings of every sort.

The famous Portuguese traveller, Dominique Paez, who visited India towards the end of the 14th century, has described in great detail the magnificence of the palaces and temples of the Vijayanagar kingdom. Describing the

shrine in the region. Through his devotional hymns he converted the people back to Hinduism. This significant turning point in the people's religious faith is recorded for posterity in these paintings.

Another significant picture is that of an Arab merchant-ship, bringing horses to a Tamil Nadu port. Muslim merchants are shown in their typical attire and headgear. The sea is depicted according to the conventions laid down in *Vishnu Dharmottaram,* with a series of swirling waves and fish below (*Plate 6*). Tamil Nadu had a flourishing maritime trade with countries like Rome, Arabia and Persia. Animals and birds like tigers, elephants, peacocks and parrots, were exported while Arab horses, which were greatly prized by the Tamil kings, were imported in exchange for costly jewels and silks. The paintings portray faithfully the costumes of the period. Kings

chitrashala inside the palace, he says "… this room is all of ivory; pillars and cross timber at the top, have roses and flowers of lotuses, all of ivory, … it is so rich and beautiful that you would hardly find anywhere another such. On this same side is designed in painting the ways of life of the men who have been here, down to the Portuguese, from which the king's wives can understand the manner in which each one lives in his own country, even to the blind and the beggars…"

There are innumerable temples all over South India with paintings which represent this period that constituted the last phase of South Indian history and culture. Such paintings can be seen in temples all over the southern region as the Vijayanagar kingdom spread far and wide, encompassing Andhra, Karnataka, Tamil Nadu, Kerala and Maharashtra, at times even touching parts of Orissa *(Plates 8 and 9)*.

The tradition of writing captions describing the painted murals was revived at this time. The earliest paintings of this genre are those found in Barhut and ascribed to the 2nd century BC. Explanatory texts describing the paintings in this temple are written in *Prakrit,* the popular language of the period. This practice which waned during the subsequent ages was revived again during the Vijayanagar period. In the *Sangitamandapam* at Tiruparuthikundram, scenes from the life of Rishaba Deva, the first *Tirthankara* and other Jain preceptors like Neminatha and Vardhamana are graphically illustrated on the outer corridor, next to the shrine. These murals have explanatory texts in Tamil. Innumerable paintings with written text in the language of the region — Tamil, Telugu or Canarese — are seen in many temples scattered over the entire South. This tradition was copied while producing cloth banners and tapestries for temple use.

The tapestry *(Plate 10)* illustrated here shows the coronation of Yudhishtira after the Kurukshetra battle that became famous as the *Mahabharata* war. Yudhishtira, the eldest of the Pandava brothers was considered an embodiment of truth and the coronation of Yudhishtira symbolises the victory of *dharma* over *adharma* (truth over untruth).

Full of details, it shows the Pandava brothers, Draupadi, Vyasa, Krishna, Satyaki and others, as well as guests, musicians and dancers. The names of all the important personages as also the general title of the picture are written in Telugu. The picture is in tempera style, painted on cloth pasted on a wooden plank.

Kalamkari tapestries based on the temple mural tradition were often huge, to accommodate the sweep of an entire epic like the *Mahabharata* or the *Ramayana*. The practice of writing legends to support the pictorial narrative became popular in the propagation of religious tenets and these scrolls were fully utilised by wandering bards and showmen, who carried the hoary tradition of Hindu culture to the masses through the visual medium of *chitrakatha* scrolls. Painted cloth banners depicting the valorous and superhuman qualities of various divinities were unfurled and set up like a temporary stage in the marketplace. Beautiful lyrics composed by saints and holymen were taken up and popularised among the general public through the twin mediums of *harikatha* and *chitrakatha* by the wandering minstrels of India.

Plate 11: Sculpture on a ruined temple inside a forest decorated with red *kumkum* dots showing signs of worship of the carved Shiva and Parvati on bull (author's collection).

A vibrant folk art of painted scrolls and pictures grew around the pilgrim centres attached to some famous temples. These painted scrolls were made as replicas of the deity inside the temple, and legends connected with the gods were painted much like the murals on temple walls.

Wandering bards made full use of these painted scrolls. Known as Patachitras, such paintings were developed as a vigorous folk culture to support the simple ballads and oral rendition of religious stories. Hindu mythology replete with imagery of the Divine provided the folk artist with an inexhaustible source of subject matter.

God is father, friend and lover, says the *Bhagavad Gita* and the relation of the human soul to the Divine can be experienced in diverse ways. Art and literature abound with instances of the imagery created by man in translating a superhuman concept into human terms. Thus have arisen the *avatars* and the stories concerning the various Divine incarnations. Even though it was argued that such an incarnation was only apparent and not real *(dehavan iva, jata iva),* to the ordinary human being it was the humanity which appealed and evoked a direct emotional response. The concept of *avatar* helps to transform the worship of the Absolute from mere philosophy into a living, attractive religion.

There is a quaint allegorical story, often related in Indian homes, which illustrates this. Bhakti Devi (devotion), it says, born in Dravida Desa, gradually grew old and lost her beauty. Her two sons, *Jnana* (knowledge) and *Vairagya* (renunciation) also became very old in course of time and lost all their appeal. Sage Narada tried to infuse youth and vigour into them by reciting the *Vedas* but it proved to no avail. He then took them to Brindavan where the youthful companions of Sri Krishna — Sanaka, Sanandana and others — recited the charming episodes of the *Bhagavata* to them and in that atmosphere of youth and beauty, Bhakti Devi and her sons regained their youthful freshness and charm.

The Bhakti cult propagated by many saints and singers was a potent force which swept the entire country in the early 20th century. The movement was carried forward by wandering bards and picture showmen, who translated and interpreted India's ancient religious heritage from learned levels to the people at large, using the local language and the art of music and painting. They moved among the common people and knew how to stir their emotions and capture

Unfinished art work chiselled by some rural artisan on rock face on a country road (author's collection).

their imagination. Common symbols and familiar activities were harnessed to drive home moral, religious and spiritual ideas.

It was a popular movement which transcended all caste distinctions. Among the Tamil Saivite and Vaishnavite bards, there were many from non-Brahmin castes which included some untouchables too. In Karnataka, Maharashtra and Gujarat, popular saints were drawn from a wide spectrum of the masses with different castes and avocations. The great poet Namadev, poet-saint of Gujarat, was a tailor, and Tukaram, was a shopkeeper. In the North, the well-loved saint, Ravidas, from Uttar Pradesh was a cobbler by trade and tanner by caste. The celebrated Kabir was a Muslim weaver from Benaras.

All these bards, irrespective of their caste, were worshipped as saints by their followers and their songs and sayings spread all over the country.

The system of pilgrimage to sacred places of worship acquired popularity. Such pilgrimages were undertaken

voluntarily with deep sincerity and austerity, whatever be the class of the people. Many shrines, with specific legends and miracles attributed to them, became popular places of worship and pilgrimage.

At these pilgrim centres, a vibrant folk culture of Patachitras (painted scrolls) developed, supporting the religious ballads. While people swayed to the music, the songs illustrated on colourful banners produced an immediate impact. The *chitrakatha* tradition (pictorial rendering) and the *harikatha* (verbal exposition) grew and gained sustenance from each other in spreading spiritual awareness among the people.

Folk belief was so strong that such pictures and symbols were invested with magic powers of the Divine, and became sacred objects in their own right. The painted scroll often became a mobile shrine which was worshipped with specific rituals, similar to those adopted in worship in the temple.

Pabuji-ki-phad

In the villages of Rajasthan, a folk-hero known as Pabuji, is worshipped. The Bhopas of Marwar have composed hundreds of ballads in praise of Pabuji and a special class of Bhopas, known as Pabuji-ka-Bhopa, have an interesting technique of reciting these songs through appropriate dance and ritual.

A scroll known as Pabuji-ki-phad, nearly 30ft in length and 5ft in breadth, profusely illustrated with the story of this brave warrior, is displayed as the Bhopas sing and recount his deeds. The *phad* is carried from place to place, rolled around a thick bamboo stick.

Followers of Pabuji, who believe in his Divine powers, commission the recital of these ballads when there is sickness or trouble in the family. They believe that the mystical power of the painting, if displayed and worshipped in their dwellings, would remove all evil influences.

The ritual is commenced by unfurling the long scroll and spreading it taut between two bamboo poles. The wife of the Bhopa places an oil-lamp in front of the scroll to invoke the spirit of Pabuji and then starts singing and dancing. The Bhopa accompanies her with an instrument known as rawanhatha and sings with his wife in a loud chorus *(Plate 13)*.

The poetry and imagery of the songs are of a very high order, even though folk in character. Pabuji is not a

Plates 13 & 14: (*top*) Bhopa singer with his folk musical instrument *ravanhatha* singing the ballads of Pabuji; (*below*) Pabuji-ki-phad, colourful religious scroll, worshiped by the Rabri tribes (*credit*: Late Devi Lal Samar, Lok Kala Mandal, Udaipur).

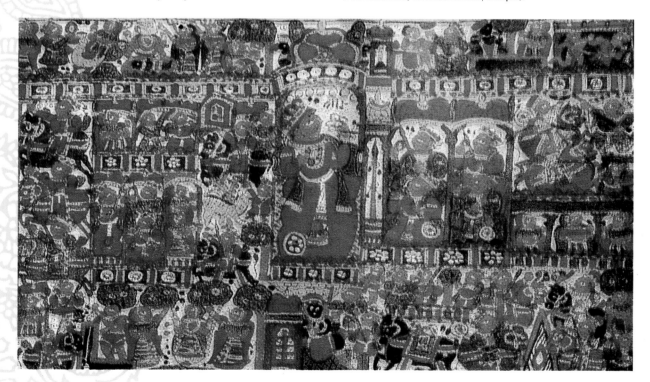

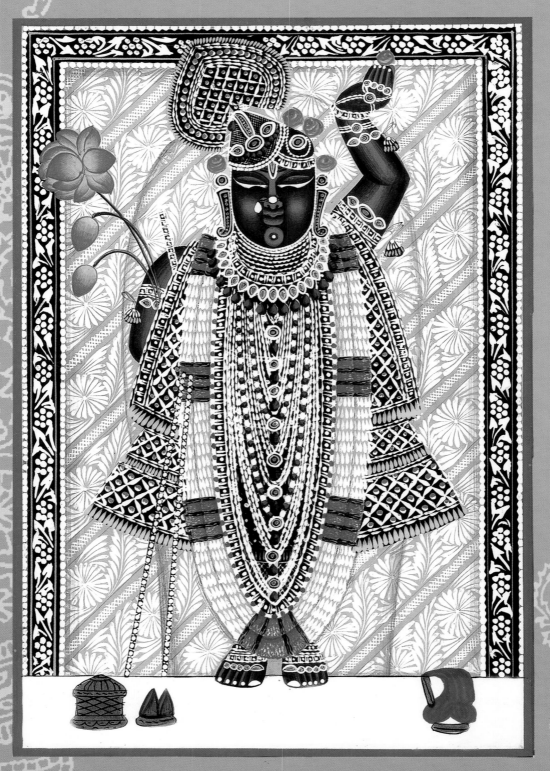

Plate 15: Painting of the deity Krishna, of the Nathdwara temple, holding aloft the Govardana Giri (*credit*: author's collection).

supernatural being but a beloved leader of the Rabari tribe, who earn their living by tending and breeding cattle. The folk-hero, who had, according to legend, sacrificed his life to protect their cattle has thus become deified as their personal God.

Like all nomadic tribes, the Rabaris, in olden days, were often harassed by another tribe, the Bundelas, when they encroached upon their territory during the dry season to seek pasture for their cattle. It was the valiant Pabuji who came to their rescue and protected them from the Bundelas. In gratitude, the Rabaris, it is said, presented him with a black mare which would neigh and alert him whenever they were in trouble. The story goes that once when Pabuji was getting married, the mare neighed and the hero left his lovely bride to rush to the rescue of his people. He fought and brought back the stolen cattle to his tribesmen. Then when the victory was being celebrated, Pabuji heard the piteous cry of a cow whose calf had been left behind in the Bundela camp. He went back once again to rescue the calf and unfortunately, in this encounter, he got killed.

A similar type of *phad* known as Devji-ki-phad is also prevalent in some parts of Mewar. Devji was also a Rajput hero of the Solanki caste and as chivalrous as Pabuji.

A big fair is held during the Dussera festival in October near Runicha, the original home of Pabuji. Thousands of his devotees collect at this place to pay homage to their beloved deity by singing and dancing. The *phad* paintings are in Rajasthani folkstyle and are vibrant with colour. The figure of Pabuji in Rajasthani style of dress with the traditional turban and coat is painted in bright red and the face often in profile. Around this figure various stories pertaining to this legend are drawn in smaller panels. The layout as well as the design of

the scrolls are similar to the traditional scrolls in which the story is illustrated in a series of rectangular panels *(Plate 14)*.

Nathdwara Picchawais

Lower down on the western coast, we come across a more sophisticated form of worship centred around Sri Krishna, the beloved deity of the masses.

These are well-known temple-paintings of Rajasthan, produced in and around the towns of Bhilwara, Shahpur and Udaipur. Lord Krishna, in various forms, is central to these religious paintings. Krishna as a young shepherd boy is worshipped in the Srinathji temple at Nathdwara on the western coast. The temple established by the Vallabhacharya cult of Vaishnavism, lays emphasis on *madhura bhakti*, or devotion through love. The Vallabhacharya sect worships Lord Krishna in his childhood form, as a cowherd playing the flute and grazing cows, or as a child stealing butter from milkmaids and dancing with the *gopikas*, in Brindavan. The most revered form, is the Divine figure of Krishna, lifting the mountain Govardhana on one finger, to provide shelter to the people of Brindavan, from the torrential rain sent down by the fury of Lord Indra *(Plate 15)*.

Towards the end of the 17th century, religious persecution by Aurangzeb forced the followers of the Vallabhacharya cult to move away from Mathura where it had been founded. They travelled southwards to find a safe place to instal the idol. After many days of travelling, the cart carrying the holy image of Sri Krishna got stuck in the mud, just on the outskirts of Udaipur. The legend goes that no amount of effort was able to shift the cart. The priests took it as a sign of God's will and built the shrine on that spot.

Unilike other pilgrim centres, the image of Srinathji is not housed in a temple but in a *haveli*, a palatial residential house. The priests stay in the same house and carry out all

the prescribed rituals. The room where the icon is kept is decorated with a Picchavai (hanging behind the image) and another drape covers the platform in front of the God. On festive occasions a painted canopy is also added over the figure of Srinathji. All these hangings consist of painted figures of the God in various activities — playing the flute, herding cows and dancing with *gopikas.*

The Nathdwara Picchavai are made both on plain cloth and on rich brocade. They are mostly pigment-painted and sometimes embroidered. Innumerable replicas of the God are made on paper and cloth and sold to the pilgrims who throng the place. Adherents of the Vallabha sect are centred mostly around Gujarat and Rajasthan in North India. Some of the affluent families of Gujarati origin maintain household shrines of Srinathji in which the image is worshipped in strict accordance with the rules of the cult.

Patachitra of Orissa

The religious tapestries of Orissa on the eastern coast of India are concentrated around the temple-town of Puri. The famous shrine of Lord Jagannath is a place of pilgrimage and the Jagannath cult, based on Krishna worship, flourishes all along the upper valley of River Mahanadi in this region.

Jagannath is regarded as 'Daru Brahma', i.e. godhead manifested in a wooden image. The word *daru* (wood) is used to indicate the world substance, symbolised in wood. The figure of Jagannath is also identified with the mystic *bija*

mantra — *Om* or *Aum*. There are many myths and legends connected with the three wooden idols installed in the temple. The primordial shape of these figures with none of the identifying marks and symbols found in other gods of the Hindu pantheon has led to controversy with each religion — Buddhist, Jain and Hindu — claiming the God as their own.

Tree worship is a very ancient cult and even today, the Savaras of Ganjam district worship the ficus tree as their *Kitung* (God). They do not cut the tree, which is known as *Jagant,* nor do they desecrate any other tree standing close to it. It is also believed that *Jagant* or *Kitung* has 10 incarnations and this is similar to the Hindu belief in the 10 incarnations of Vishnu. The name Jagannath is therefore ascribed to the Sanskritised form of *Jaganta.*

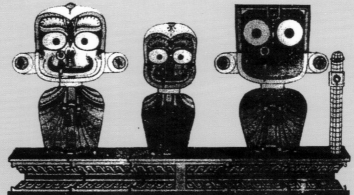

Plate 16: Wooden idols worshipped in the Jagannath temple at Puri (author's collection).

It is this tribal base which accounts for the strong tribal features of the idols worshipped in the temple *(Plate 16).* The spread of Vaishnavism during Gupta rule, transformed the tribal cult into a sophisticated form of worship and from the 5th century AD onwards, Lord Jagannath became associated with the divine figure of Sri Krishna.

The shrine of Lord Jagannath was visited by great saints like Sankara, Ramananda, Ramanuja, Madhava Tirtha, Nanak and Chaitanya. It is said that the identity of the deity was firmly established by Sankaracharya who consecrated the God in the name of Jagannath. The temple gained popularity during the rule of Ganga dynasty in Orissa in the early part of the 12th century. Following Turkish invasion, neighbouriung

regions of Orissa were occupied by the Muslims, but Orissa itself remained a strong, independent Hindu kingdom. Faithful Hindu pilgrims flocked to Puri to conduct religious festivals unmolested, with worshippers of different cults, paying homage to Sri Jagannath (Lord of the World). It is surprising how diverse cults of Hinduism which were sometimes antagonistic to each other were wedded together in the worship of the deity at Puri. Puri, Bhubaneswar, Konark, Mahavinayaka and Jajpur were the respective centres of five different branches of Hindu worship: Saivism (worship of Shiva), Vaishnavism (worship of Vishnu), Sauram (worship of the Sun-god), Ganapatyam (worship of Lord Ganesa) and Shaktam (worship of Devi Shakti). It was a cosmopolitan worship aimed at synthesis by adopting principles from all these cults.

The huge temple in Puri, a major city in Orissa state, has now developed into a regular Hindu place of worship where Vedic rituals and ceremonies are performed.

The main idols being made of wood, need to be replaced from time to time. Custodians of the idols in the temple, known as Daitas, belong to the Savara tribe. It is their duty to take care of the idols and perform the *snana yagna* (bathing ritual) and the car festival, which is celebrated with pomp and show when the images are taken out in a mammoth, beautifully decorated chariot. This temple-chariot is so grand and awe-inspiring that the word 'juggernaut' (from Jagannath) has

become part of the English language to describe all temple chariots, which are drawn by a multitude of inspired devotees. When the idols are to be replaced, the old ones are destroyed in a ritual known as *nabalekabar* which is akin to a funeral and is performed every 12 or 18 years by the Daitas.

The spectacular Puri car-festival attracts many pilgrims to the area and Patachitras based on the Krishna legend are painted and sold around the precincts of the temple. The artist's colony, known as *chitrakarsati* surrounds the main temple. The painting is done on cloth, which is cut to size and stiffened with a coating prepared from chalk powder and tamarind-seed gum. This gives the cloth a smooth leathery surface on which the *chitrakars* (artists) paint the figures with earth and mineral powders *(Plate 17)*. Paintings of gods and goddesses of the Hindu pantheon other than that of Lord Jagannath are also made to meet the demands of pilgrims. These are individual figures and do not tell a story as seen in Kalamkari paintings.

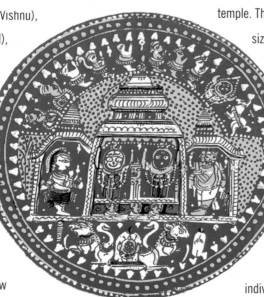

Plate 17: Patachitra of Lord Jagannath
(courtesy: Salar Jung Museum, Hyderabad).

Madhubani

In Madhubani or Mithila painting, pictures of various household deities are drawn by the housewife on the walls of the house as a direct form of worship. These drawings are made on ceremonial and festive occasions as auspicious symbols during a marriage, the cradling of a baby, or a religious function like the sacred thread ceremony of the Brahmins. Arising out of the *bhitti-chitra* tradition of wall-

paintings, this folk art is centred around villages in northern Bihar and not attached to any temple. Paintings are made on the walls of residential houses or on paper *(Plate 18)*. Mysticism, folklore and regional versions of Hindu epics form the basis of these pictures, reflecting a deeply personal religion and method of worship.

A great cultural centre, Mithila has been home to renowned philosophers, like Yagnyavalkya, Kapila and Jaimini, who propounded different schools of thought in Hindu religion. Vaisali, another great city in this region, was well known as a centre for Jain and Buddhist philosophy. It is not surprising therefore that the people of this region are deeply religious and their customs and daily life are imbued with mysticism and religious symbols.

The influence of Goddess Kali and the Tantra tradition is predominant in the rituals, invocations, floor-drawings and wall-paintings of Mithila. While religious paintings include all the gods and goddesses, the secular paintings contain symbols which are considered auspicious, like the elephant, horse, fish, lion, parrot, turtle, etc. and sacred motifs like the *swastika* and *shankh* (conch).

These paintings are generally executed in specific parts of the house on special occasions. Walls of the room where the family deities are worshipped *(gosain-ka-ghar)* are decorated with figures of all the deities — Durga, Shiva, Rama, Sita, Krishna, Ganesa, the 10 *avatars*, as well as the sun and moon. Weddings are occasions for a spurt in painting activity. The nuptial chamber *(kohabara ghar)* of the newlywed is made auspicious by drawing the sun and moon, a bamboo tree, circle of lotuses, parrots, turtles and fish. The bamboo and lotus are fertility symbols, which are protected by other auspicious drawings. Parrots are often considered birds of love

and feature in many love songs as messengers of love. The main colour used for these drawings is vermillion red as it is considered auspicious.

Madhubani folk painting reveals a strong relation between this art and religion. *Vratas* (religious fasts) and festivals are the motivating factors, which have given rise to pictures produced as a form of worship and as a part of ritual. Madhubani paintings can be classified under three heads: wall paintings *(bhitti-chitra)*, canvas painting *(patachitra)* and floor painting *(aripana)*. Decorating the floor and walls of their houses on all religious and festive occasions is part of every ceremony in a Madhubani household.

It is a co-operative community art which is executed by the more skilful women of the caste, while others fill in the decorative details. Younger girls stand by to help and learn the nuances of the art and significance of the motifs without any particular training. It is considered a purely domestic art, like cooking or needlework.

Since Madhubani painting is a ritual act and an integral part of certain rites performed in the family on religious and social occasions, the designs always conform to a set pattern and follow ancestral ways in depicting the figures. Modern paints and colours are unknown and traditional methods of painting with indigenous materials are still in vogue. The colour black is derived from soot obtained by burning *jowar* (barley) as well as lamp-soot. This is mixed with the sticky kernel of the *bel* fruit, with cowdung added, to thicken the mixture. Turmeric powder is used for yellow, and the juice of *kusum* flowers for red. Similarly, green is obtained from the juice of the leaves of the bel tree. White is obtained from slaked lime powder. The colours are applied to the freehand drawing , using ordinary sticks and sometimes with the fingers.

colours and designs were worn by the people. These draperies show that the designs were produced with surface patterning on woven cloth, and were not patterned on the loom. Patterns were produced both by freehand drawing and through block printing. Along with religious scrolls prepared for temple use, richly patterned textiles were produced for use by kings and nobles. The Kalamkari craftsmen were adept at patterning with the pen, and clothes designed for the aristocracy were produced entirely by freehand painting executed with colourful vegetable dyes. A distinctive style based on freehand painting with vegetable dyes and resist printing with wax on an intricate weave was developed in a village near Tanjore, known as Kodali Karuppur. These Karuppur saris were so beautifully fashioned and so expensive that they were reserved only for women of the royal household. Craftsmen of the Tanjore region were highly skilled in block printing,

Plate 24: Fragement of an old sari from the Tanjore region patterned with wax-resist and dyed in indigo vegetable dye (*courtesy*: Government Museum, Chennai).

especially in the resist method of printing with wax (*Plates 23 and 24*).

When Alexandar the Great invaded India, in 327 BC we are told that he was captivated by the colourful garments worn by the Indian people. Through repeated invasions, he established new trade routes, and Indian fabrics in vast quantities, along with spices and other commodities, were exported to the capitals of Europe. Markets were established throughout Asia, Egypt and Greece for fine Indian muslins and richly coloured fabrics of India. Arab traders in the 2nd century AD brought Indian fabrics to Europe via the Red Sea, and extended the trade routes into Central and West Africa, ensuring worldwide spread of Indian textiles.

It is obvious that long before the Christian era, the art of textile dyeing and printing had been in existence in India, not only as a religious art, but also as colourful textiles, painted using vegetables dyes (*Plates 25* and *26*). The distinctive name of Kalamkari, however, came into use only during Muslim rule. The Sultans of Golconda, who came upon this craft tucked away in the southernmost corner of the kingdom, were captivated by the brilliant colours and exquisite designs created with the aid of a simple tool, the *kalam*. They thus dubbed the artisans who worked with the pen, as *qalamkars*, and the product came to be categorised as *qalamkari*. Until then, the technique did not have a name, and was known only by the name of the various products that it produced. Baptised as Kalamkari by the rulers of the Qutb Shahi dynasty, it now had an identity, which was later to blossom into an international art form.

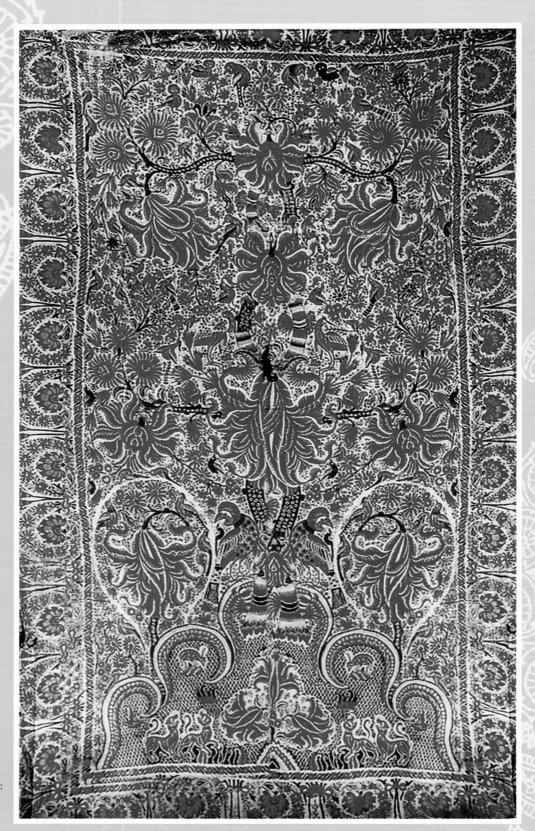

Plate 25: Hand-painted curtain in brilliant red *chayaver* vegetable dye from the Kodali Karuppur region of Tanjore (*courtesy*: Government Museum, Chennai).

Plate 26: Block-printed Kalamkari bedspread from Masulipatnam (*courtesy*: Government Museum, Chennai).

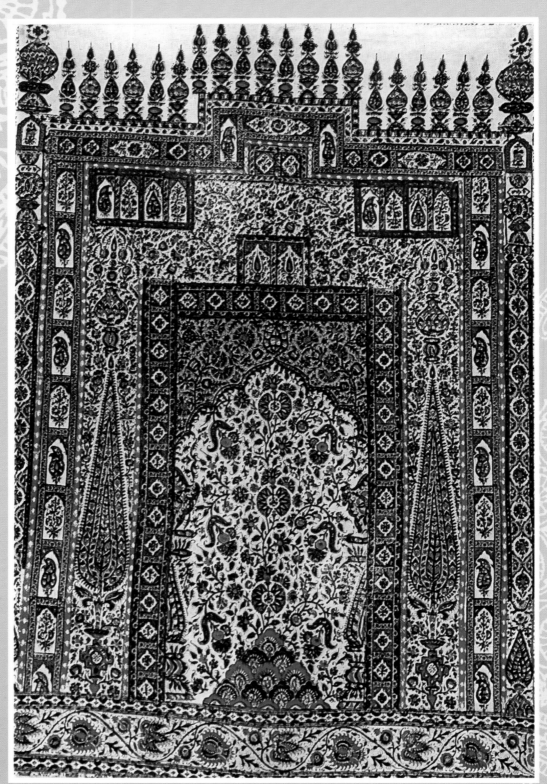

Plate 27: Muslim prayer mat, block printed, from the Golconda region (*courtesy*: Government Museum, Chennai).

Mughal invasion of India in the 16th century, brought Persian art into the country but instead of dominating the indigenous art, it was transformed by Indian influences into a distinctive art with its own unique character.

The first transformation of the Kalamkari tradition came under Muslim influence, under which the technique and colourful dyes were used to produce textiles with Iranian motifs *(Plate 27)*. Craftsmen from Iran, and carpet designers known as *naqqash*, were brought to India, and settled in the capital of Golconda. Production of Kalamkari cloth was started on a large scale in *karkhanas* (workshops) set up for the purpose by the king and the nobles. Iranian motifs were incorporated during this time and a variety of floor coverings, curtains and colourful patterned sashes and *rumals* (kerchiefs) favoured by the Sultans, were produced. These Kalamkari textiles, known as Golconda cottons, formed part of

a flourishing trade and the main harbour for handling these exports was the city of Masulipatnam on the Andhra coast. Other main Kalamkari centres on the Coromandel coast were Palakollu, Pulicat and Nagapattinam. Demand for Kalamkari fabrics grew over the years and many mechanical aids were introduced by the Persian designers to enable Indian craftsmen, to increase production. The system of punched tracings, traditionally used in Iran, was introduced to stencil the patterns on to cloth. This was followed later by the use of hand-carved wooden blocks. Freehand drawing of the earlier tradition was however, not totally given up, because Kalamkari craftsmen still continued to use the *kalam* for design embellishment and application of certain colours, like yellow.

The beautiful fabrics produced and exported in this period caught the imagination of Western countries. European nations had well-established trade links with India even before this time, but now, when the popularity and demand for these textiles increased, they wanted to ensure supplies by establishing their own factories and workshops, where they could control the production. In this race for commercial supremacy, many European powers — the French, the Dutch, the Portuguese and the English became rival combatants. The British East India Company was founded in AD 1600. The Danes followed quickly on their footsteps, establishing the Danish East Asiatic Company, in 1616. Soon, the French also entered the arena,

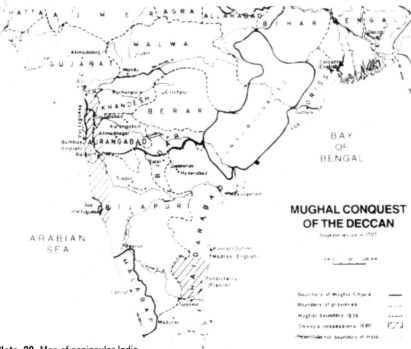

MUGHAL CONQUEST
OF THE DECCAN

Plate 28: Map of peninsular India showing British, Dutch and French settlements all along the coast.

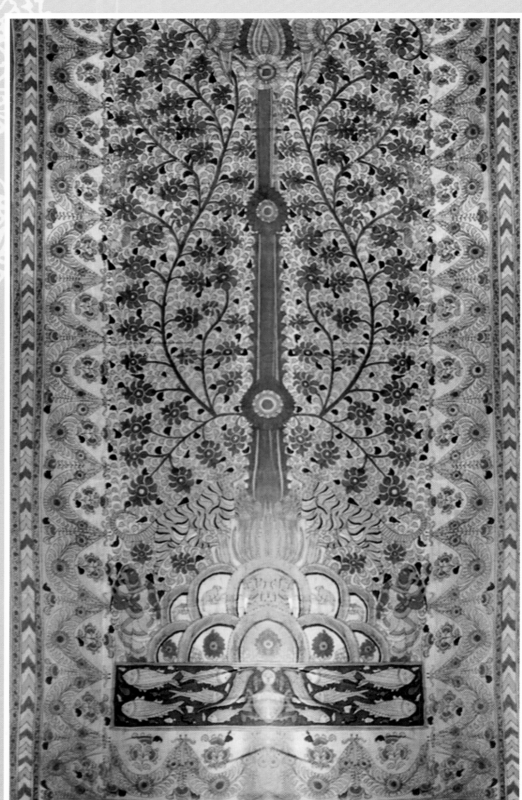

Plate 29: Hand-painted Kalamkari curtain from the Dutch settlement at Nagapattinam (*courtesy*: Government Museum, Chennai).

establishing in 1664 the French Campagnie Des Indes Orientales. The Portuguese had been the first on the scene, and had established bases, both on the east and the west coast of India *(Plate 28)*. There was much bartering and exchange of land between the Portuguese and the East India Company, which was slowly consolidating its empire. It is interesting to note how the city of Bombay was gifted by the Portuguese to the English, for a paltry annual rent of $ 10, when Charles Stuart of England married Catherine Braganza of Portugal.

The English set up an office and production base in Masulipatnam as early as in 1611. They then expanded their operations by setting up another base near Madras (now called Chennai) close to the Portuguese settlements of Santhome. The East India Company had started out only as a trading concern of a few merchants in London in 1600, but within the course of a 100 years, the company grew into a prosperous and powerful national body. It was invested by a royal charter, with powers "to seize and send home interlopers, to wage war and conclude peace with non-Christian princes, to appoint Governors who in conjunction with their councils were to exercise civil and criminal jurisdiction at the various settlements." A trading company thus became a major political power, laying the foundation for the British Empire in India.

Kalamkari fabrics, dubbed as chintz, by English traders, formed a major part of trade of the East India Company. The Dutch termed these fabrics as *pintadoes* and the French as *Indiannes* (*Plate 29*). For two whole centuries, from 1600 to 1800, India became the greatest exporter in the world, and her colourful fabrics penetrated every nook and corner of the civilised world. The main appeal of Indian chintz to European buyers was the brilliance and fastness of its colours. The only painted and printed fabrics made in Europe at that time were primitive in technique. In Tudor England, insoluble pigments were applied to linen cloth to produce patterned hangings. Another method was to print with printer's ink, which was fugitive and did not stand up to washing. A few vegetable dyes, like logwood for black, and Woad for blue, were being used by Western craftsmen, but the colours were inferior to Indian dyes like indigo. So, indigo became a major component of imports from India. Red and purple colours in the West were obtained from insect dyes, which required enormous quantities of the base dyestuff, and were therefore prohibitively expensive. Also, much of the knowledge of fixing the dyes to cotton had not developed in these countries, which made Indian chintz with its sunburst of colours very popular.

The Coromandel cloths in colour-fast designs were a great source of wonder and it is not surprising that for several centuries, the entire world was in the grip of a calico craze, with the sole supplier being India. The East India Company became powerful and rich through trade in Indian muslins which became the most sought after fabric, not only for curtains and bedspreads, but also for personal garments. Growth of this fashion and passion for Indian fabrics is described with great sarcasm, by the English writer, Daniel Defoe, who had started his career, in the clothing trade, and was a critic of the East India Company. He wrote, ".... chintz and painted calicos, which were before made use of only for carpets, quilts, etc., have now become the dress of our ladies, and such is the power of a mode; we see our persons of quality dressed in Indian carpets, which not a few years before, their chambermaids would have thought too ordinary for them; the chintz have advanced from lying on their floors to their backs, from the footcloth to the petticoat..."

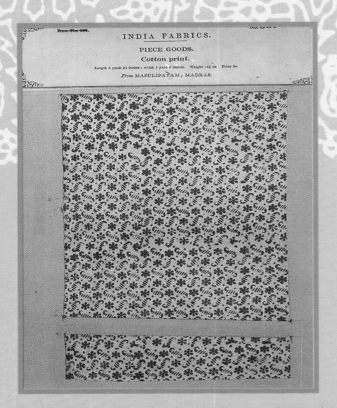

Plate 30 a, b, c & d: Fabric sample from the Forbes Watson Catalogue (*courtesy*: Government Museum, Chennai).

Many efforts were made by the Europeans to learn the technique of producing these colours and fixing them to cloth, as can be seen from this letter written by a Christian missionary who spent almost 50 years in Pondicherry, and was conversant with Tamil and Telugu. This letter in French written by Father Gaston Laurent Coeurodoux to Father Du Halde in Paris is a detailed account of the Kalamkari technique followed by Indian craftsmen. The letter in which he describes the method, step by step, accompanied by actual cloth samples, was later translated into English, and printed in G.P. Baker's book, *Calico Painting and Printing in the East Indies* in the 17th and 18th centuries.

The Father, who went to considerable trouble to discover the secrets of the craft, wrote:

"... Knowledge acquired here, if transmitted to Europe, would possibly contribute to the progress of science and perfection of the art. I have used my leisure to find out the way in which Indians make these beautiful cloths, which form part of those companies established to extend commerce. These cloths acquire their value and prize from their brightness, and if I may say so, from the solidity and fastness of the colours they are dyed with and which so far from losing their brilliance by washing, actually grow more beautiful. The reason why European industry has not yet reached this point as far as I know, is not for want of research on the part of our own skilled men of science, but it would seem that the author of Nature, as a set off against other advantages which Europe enjoys, has granted India ingredients, and above all certain waters whose particular qualities have much to do with beautiful

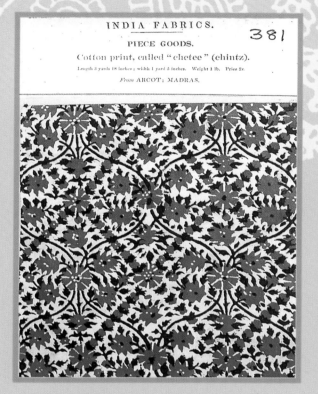

combination of painting and dyeing, represented by Indian cloth. What I have to tell you, my Reverend Father, on these Indian paintings has been learned from various neophytes skilful in this sort of work, on whom I recently confirmed baptism. I have questioned them frequently and separately, and it is their replies that I am now sending you."

Not only did Father Coeurdoux investigate the process step-by-step in great detail, but he also procured samples of the herbs used, like *kadukka* (myrobalam). He also suggests that seeds of the chayaver plant could be planted in France and the plant studied and used for its tinctorial quality, for which the Father enclosed a drawing painted from life, of the chayaver plant.

It is interesting to note that the roots of the chayaver plant were used for producing the famous red colouring in the textiles of Madurai and Father Coeurdeux joined the mission in

Madurai in 1732, after which he worked in Pondicherry and Karaikal, the centres for Kalamkari painting. His protracted residence in these parts and familiarity with the language made him conversant with the technique of Kalamkari. It is however, not certain whether these techniques were followed by printers in Europe.

Father Coeurdeux's letter was translated into English, Dutch and German, at various times, which indicates the deep interest shown in the Indian methods of colouring and printing textiles. Another well-known treatise on cotton painting, at the library of the museum, National d'Histoire Naturalle, Paris contains 12 pages of text on the Kalamkari craft, accompanied by 11 sample pieces. This document, which served as reference for many producers in Europe, was initiated by a famous colour-chemist of the period — M. Dufay, and a well-known textile manufacturer, Jean Ryhiner of Basle. This investigation also recorded a step-by-step account of

the process, conducted by M. de Beaulieu, a ship's midshipman, who travelled five times to Pondicherry to collect this information. Pondicherry was a French dominion, and it is not surprising that investigators from France chose this area for their research. The East India Company with factories in Masulipatnam, Madras, Nagapattinam, and other places on the coast, was more interested in whipping up the manufacture for increasing trade rather than in learning the craft. The demand far exceeded the supply, and procuring goods to meet bulk orders took up all the Company's energy, and drove the officers to distraction. The Kalamkari process was tedious and time consuming, and largely dependent on the weather conditions. The craftsmen were often unable to meet the demands of their British overlords. Desperation and frustration of the British are reflected in a host of letters, which constitute part of the East India Company official records:

"The prosperous is daily expected from Masulipatnam, with more paintings, but the weather is so bad, that the washers are unable to 'cure' those already in hand."

The spreading of the cloths in the process of manufacture on the bed of a river, to bleach and cure, often led to their being washed away by unexpected floods, which was the lament of another letter.

Production was slow and craftsmen were limited. There was much competition among the various European settlers to ensure a steady flow of their production requirements by holding on to their own group of craftsmen, who were threatened and cajoled by turns to sustain optimum production. Artisans' quarters, known as 'black towns', were built by the East India Company in Fort St. George (Madras) and craftsmen were offered paddy and money advances to keep them happy and under control. Similarly, the Dutch had settlements in Nizampatnam in Andhra Pradesh and the Danes had their

workshops in Cuddalore. Craftsmen who tried to leave were severely punished and brought back, and rival European companies looked with suspicion, on such disappearances, accusing each other of malpractices.

A letter from Masulipatnam, in the East India Company record of 1636, says: "The painters which wrought these musters, are by the Governor's ill usage gone to some other place, and cannot be traced, but it is hoped that the work will be resumed soon."

In spite of all these problems in procurement, trade flourished and grew so rapidly that the British government had to ban import of Indian textiles by law, in order to protect their own textile industry. In 1710, a legislation was passed prohibiting the sale of Indian goods, either as apparel, or for furnishing, with a penalty of £ 200. Indigo dye had also been a major item of export and constituted a threat to the indigenous woad dye manufacturers in Europe. They tried to discourage imports by condemning indigo as the 'devil's eye', harmful and corrosive. The import of chintz in the 17th and 18th centuries not only revolutionised taste and fashion, but also challenged the very economic stability of governments of major Western powers, like England, France and Portugal. In order to protect their domestic industry, laws similar to those passed by England were enacted in France, Spain and Germany. In the East, Japan also took remedial action against imported fabrics by prohibiting entry of foreign goods, which remained in force from 1640 to 1840. Last to join this worldwide ban was Persia, which proscribed Indian Kalamkari in the year 1924. In spite of the ban, interest in Indian chintz did not wane and fabrics were sometimes smuggled by designers to meet the demand. However, the earlier frenzied tempo of manufacture was considerably slowed down. Production of Kalamkari, which was

promoted with such vigour, started to decline, and many craftsmen were thrown out of their jobs.

In the 19th century, the Industrial Revolution in England, led to the establishment of textile mills in Leeds and Manchester. Weaving of cloth was taken up on a large scale and markets had to be developed for British millmade goods. The commercial policy of the British in India now underwent a change. The growing of raw cotton was encouraged and cotton was exported to England to feed the textile mills there. Efforts were also made to increase the production of indigo by setting up factories all over India, especially in Bihar and Bengal for production of the dye, which was required in larger quantities now, to dye the textiles manufactured in England and other places. Finished goods were sent back to the Indian markets for sale. By the end of the century, machine-made cloth from Lancashire and Manchester flooded the Indian markets.

There was some initial resistance to these foreign goods among the Indian populace. Determined to capture the Indian market, the British made a thorough study of the wearing habits of the people, so that suitable goods could be produced in their mills and which would sell.

Indian costumes consisted mostly of unstitched material like *dhotis* and saris. The British made an intensive study of such designs and found that Indians preferred material with borders attached. Colours and prints of the Coromandel coast were also investigated and documented. A monumental textile survey pertaining to every region in India was undertaken, under the supervision of Dr J. Forbes Watson for the India Museum in London *(Plate 30)*. E.B. Havell, who undertook industrial tours of the printing centres in Madras Presidency, has left copious notes on textiles worn and vegetable dyestuffs used. Edgar Thurston, who was superintendent of the Government Museum in Madras, and W.S. Hadaway, made detailed surveys and collected samples of traditional textiles for the museum. In their methodical and meticulous fashion, the British have left detailed records, which now form a reliable base and source material for the textile industry of that period.

Early in the 20th century, chemical dyes were discovered and the technology of dyeing and printing began growing by leaps and bounds. Natural dyes in any case were not sufficient to meet the enormous pressure of mill-manufactured products. It is thus not surprising that the people gradually turned away from the laborious style of the Kalamkari style of printing. The impact on the Kalamkari craftsmen was tragic. After reaching great heights and being forced to grow beyond their customary rural boundary, the craftsmen, uprooted and left without jobs, began to die of starvation and penury. A famine occurred in the southern districts in the year 1940, in which it is recorded that more than ten million people died of starvation.

The craft tradition in India is an oral tradition, in which craftsmen learned the technique by word of mouth, through generations, passed down as a secret lore from father to son. Hence, it is not surprising that knowledge of the Kalamkari craft died along with the craftsmen. It is said that more than 300 colouring herbs were known and used in ancient times, which dwindled from lack of use over the centuries. Now we have hardly a dozen known sources of vegetable dyes for the use of craftsmen. The craft now survives in isolated pockets of Masulipatnam, Kalahasti, Salem and Kumbakonam. It has, however, lost its earlier magnificence and only the tattered remains of a once-vibrant tradition are now seen.

Painted and Printed Textiles

There are two main styles in Kalamkari painting — one is the earlier fully hand-painted style, which is essentially narrative in character, and often religious. The other style is the block-printed style, which has wider application in garments and articles of everyday use. The major centre for hand-painted Kalamkari is the temple town of Sri Kalahasti and that for the block-printed style is the port-town of Masulipatnam. Both these cities are in Andhra Pradesh.

Hand-painted Style

The temple Kalamkari was an extension of the mural tradition, following the same style of narrative presentation and figurative design elements. These long cloth banners were used as drapes inside the temple premises and at times to decorate the temple-chariots *(ratham)* when the idol of God was taken out in a procession *(Plate 31)*. Depending on the use to which they were put, Kalamkari painted cloths were produced in different sizes and forms.

Unlike the Patachitras, which were based on a single theme or Divine figure, Kalamkari pictures drew inspiration from a variety of mythological subjects. Entire epics, like the *Ramayana*, the *Mahabharata* and the *Bhagavata Purana* were presented in pictorial form. Such Kalamkari scrolls were huge in dimension, sometimes even extending up to 30 feet in length and 3 to 4 feet in width. The artist was

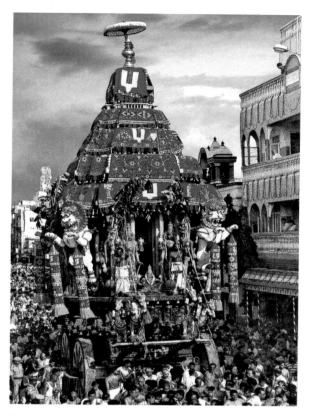

Plate 31: Temple chariot decorated with Kalamkari festoons,

Even though the paintings were based on a basic story line, like the *Ramayana for* instance, each artist emphasised and drew the episodes according to his own individual interpretation. Some episodes in the story would be passed over quickly, while some would be emphasised. The entire story was laid out in rectangular panels (like those in present-day comics) surrounding the main theme depicted in a square or circular panel in the centre. For example, in the *Ramayana*, the coronation scene occupies centre place in which all the main characters of the story are shown *(Plate 32)*. Rama and Sita are seated on the throne, while Rama's brothers surround them, and the faithful Hanuman pays obeisance at Rama's feet. Similarly, in the *Mahabharata*, the 'Viswaroopa Darshan of Lord Sri Krishna' expounding the *Gita* occupies the central place, and the Pandava-Kaurava story is depicted all around culminating in the battle of Kurukshetra *(Plate 33)*.

able to encapsulate the wide sweep of the epic into segments, in which each episode was illustrated with appropriate pictures and descriptive headings written in Telugu or Tamil. For those who knew the story, these written lines were sufficient to understand the episode in its entirety, because stories from the epics were so well known and so much a part of daily life and ritual that even the illiterate rural folk understood the episodes, without any elaboration.

"Tradition is a wonderful expressive language that enables the artist working through it to speak directly to the heart, without the necessity for explanation. It is a mother tongue; every phrase of it is rich with the countless shades of meaning read into it, by the simple and the great, that have made and used it in the past," said Ananda Coomaraswamy, describing Indian art.

Selection of episodes and emphasis on certain events are inspirational and subjective, depending on the imagination and approach of individual artists. This can be seen in the mural tradition also, as is evident in the illustration of a 17th century mural painting from the Chengam temple. Hanuman is seen dragging Ravana's wife, Mandodari by her hair, after the victory of Rama in battle *(Plate 34)*. This episode is not described in any *Ramayana* text, written either by Valmiki or Kamban, but seems to reflect the artist's own vehement assertion and unholy glee at the outcome of the war, and downfall of the despised Ravana!

The same Rama-Ravana *yuddha*, 'battle episode', is painted differently in a 200-year old Kalamkari painting from the Government Museum in Chennai *(Plate 35)*. This tapestry, probably of the 18 century is similar to the Kalamkari scrolls of the Palakollu region. Brittle with age and much tattered, the visible portions are still vibrant with colour.

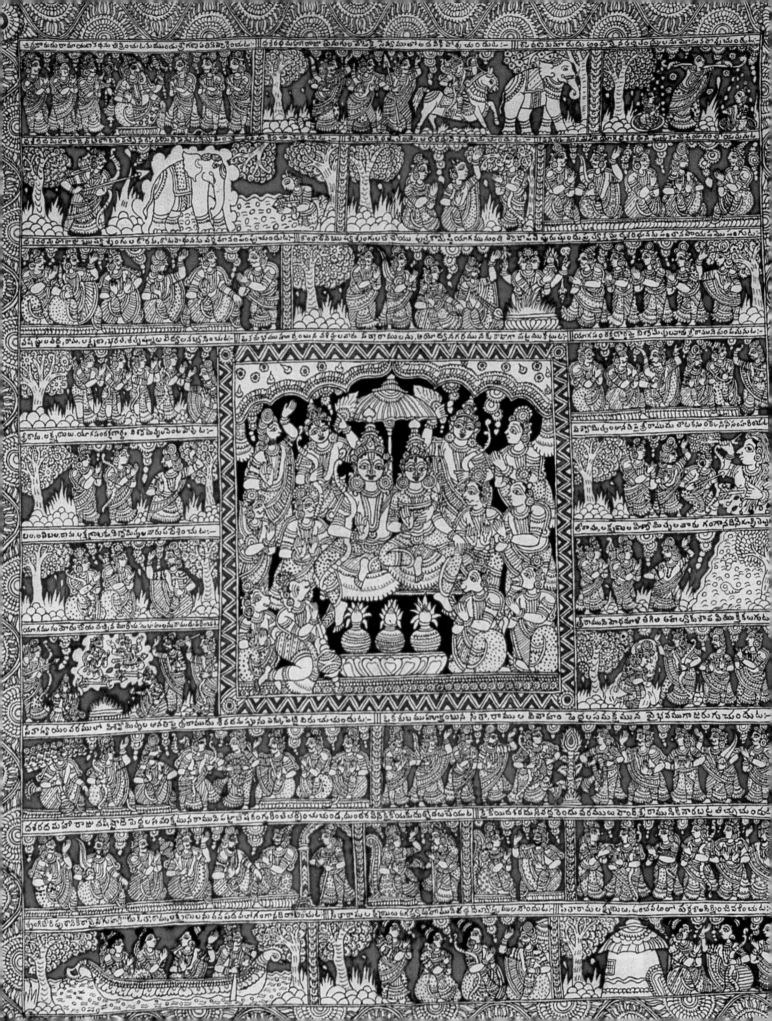

Plate 32: Contemporary Kalamkari painting of the Balakandam episodes from *Ramayana* (*courtesy*: C.E & R.C. Kalakshetra Foundation), (facing page).

Plate 33: A very old Kalamkari *asmanagiri* tapestry used on the ceiling of a Vishnu temple in Andhra Pradesh (*photograph*: author's collection).

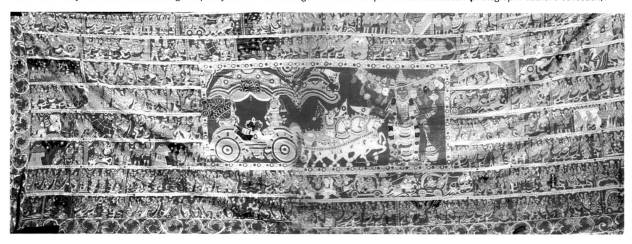

Plate 34: *Ramayana* mural painting from the Chenjam temple, 17th century (*courtesy*: Archaeological Survey of India).

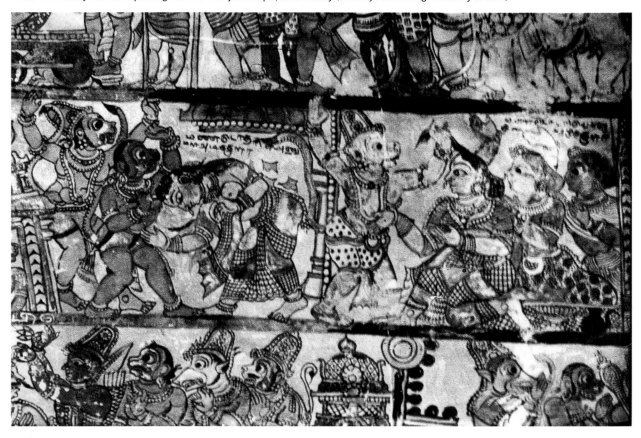

Sampoorna Ramayana

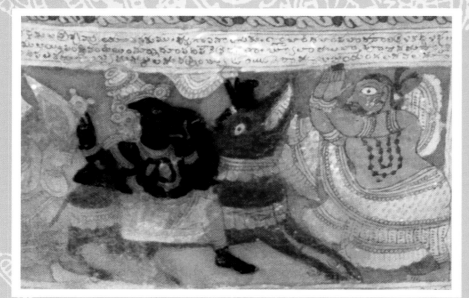

Plate 35 a to I: Panels from old Kalamkari tapestry illustrating *Sampoorna Ramayana* (*courtesy*: Government Museum, Chennai).

a. Lord Ganesa on the *mooshika vahanam.*

b. Sage Narada meets Maharishi Valmiki ensconced in a termite mound and requests him to write the story of *Ramayana*.

c. *Devas* seek Lord Vishnu's help to conquer Ravana.

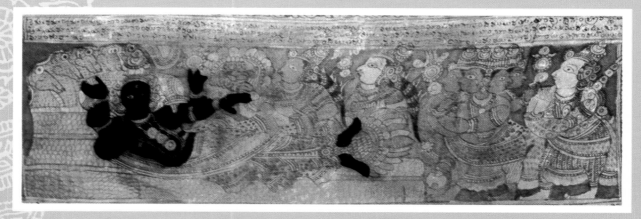

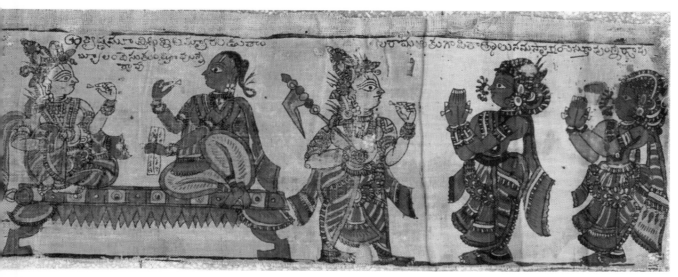

c. Krishna and Balarama playing dice.

d. *Gopikas* greet Krishna.

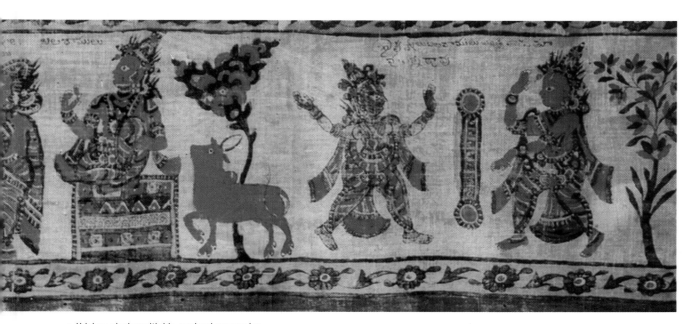

g. Krishna playing with his cowherd companion.

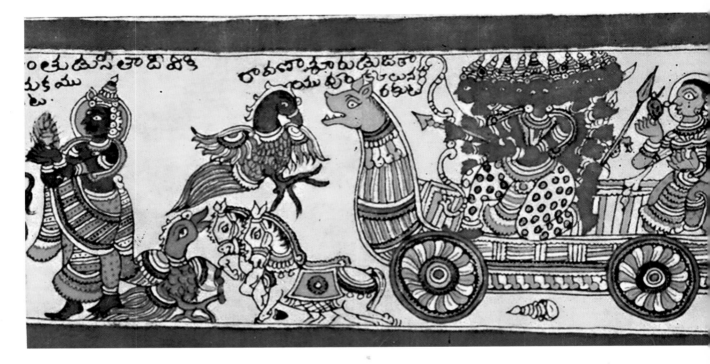

Plates 44 & 45: Fragments of old tapestries from Tanjore region, dating back to the 18th century, illustrating episodes from the *Ramayana* (*courtesy*: Kalahasti Kalamkari Kalarula Sangam).

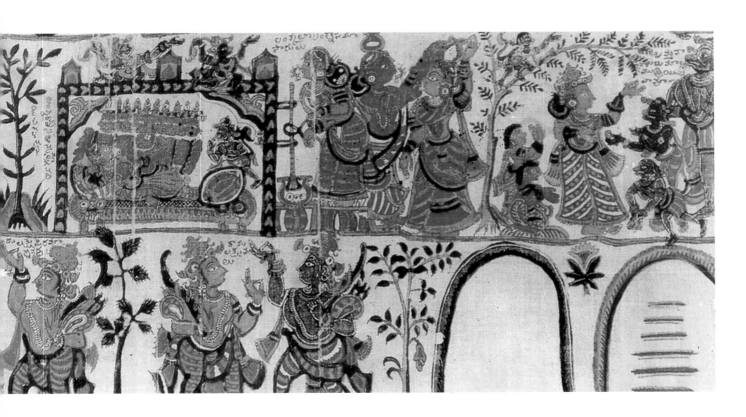

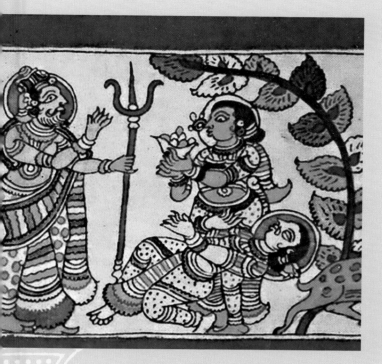

earlier date. Tanjore, which was part of the Vijayanagar principality, came under the Bijapur Sultanate towards the closing years of the century, when Nayak rule came to an end.

Venkaji, the trusted Maharatta General of the Bijapur Sultan, was placed on the throne of Tanjore, and Maharatta cultural traditions mixed with the local idiom, which subsequently imbibed European traditions also, during British rule in the 18th century. In the Sikkinaickenpet Kalamkari paintings, the impact of different cultures can be seen in the layout of the designs, in which architectural details and *mandaps* are drawn similar to the miniature paintings of the North. Flying *kinnaras* are shown with wings, and dressed in Maharashtrian-style saris. Brick flooring, draped curtains on top of the picture, and naturalistic flower patterns on the border, which is typically British in style show an amalgamation of the styles of different periods (*Plates 46, 47,* and *48*).

figures stand out against a white or coloured background. The borders are not as elaborate as in the Kalahasti style. The deep maroon, black and blue background of the Kalahasti style is missing; instead, the background consists of small flowers or dotted motifs on a white or yellow background which gives a brighter look to the paintings.

A 100-year old painting from the Kumbakonam region, at present in the Government Museum in Madras, illustrates episodes from the Krishna Lila from the *Bhagavatam*. The Telugu script explaining the episodes is written informally, next to the figures, without the usual convention of a top border carrying the text (*Plate 43*). The same style is evident also in tapestries from the Palakollu region.(*Plates 44* and *45*). The people of Tanjore in the 17th and 18th centuries were a heterogeneous community of Tamil, Telugu and Marathi-speaking people, and Telugu was the state language. Many of the paintings therefore were captioned in Telugu, even though produced in the Tamil region. Tamil captions are found only in temple murals, which obviously belong to an

Plate 46: Krishna with butter pot in typical Tanjore style, contemporary—Sikkinaickenpet (*courtesy* Radhakrishna Naidu).

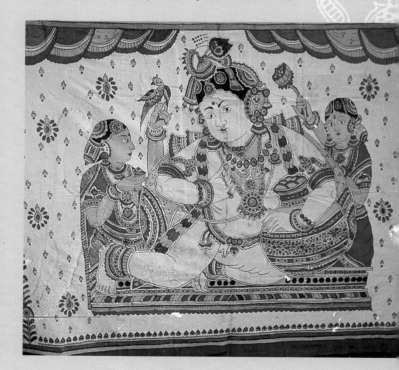

In present times, Kalamkari artists have given expression to a variety of subjects other than those from Hindu religious texts. The Samson and Delilah story from the Old Testament (*Plate 49*) and animal fables from the *Panchatantra* (*Plate 50*) are totally different from the usual subjects, but the style and character of the tapestry are very traditional.

A common feature in the painted styles of Kalamkari is the strict adherence to the pen or *the kalam*. Even border designs are not repeated. The technique of painting with vegetable dyes was also maintained. The Kalamkari craftsman scorned mechanical aids and was most comfortable only when he could give free rein to his imagination through free-hand drawing.

Printed Style

The fully hand-painted tradition of temple Kalamkari gave way to the block-printed style in later centuries, moving away from its religious moorings. It was synonymous with the emergence of craft centres and guilds that were set up by the Mughal emperors, who were great lovers of beauty. Their intervention in the Kalamkari tradition lifted this craft from its strong village identity and made it a sophisticated art for the urban people. Realising the great potential of this textile craft with its beautiful colours, Mughal princes adopted the technique for producing material for their palaces and tents. One of the chief uses of cotton paintings in the Mughal period was for tent hangings. It was customary for the ruler to undertake tours to all parts of his kingdom, not only on matters of state, but also during times of war and hunting expeditions. The tents therefore were luxurious, designed with comfort in mind, and lined with beautiful tapestries to suit the opulent tastes of the Mughal Sultans. Francois Bernier, the French traveller, who travelled in the South, some time in the 17th century, has left detailed accounts of fine cotton paintings, which he saw in the tents of the Sultan. "The private tents of the king," he says, "are lined with painted chittis, of very fine workmanship of Masulipatnam, which represent a hundred different sorts of flowers, and the work is refined with gold and silver thread".

Masulipatnam was the main centre in the middle of the 17th century for a flourishing trade with cities like Persia, Turkey, Arabia, and Egypt. The Kalamkari technique was used by Muslim Sultans, not only for tent canopies, but for many export fabrics — men's gowns, waistcoats, women's dresses and petticoats. The inspiration behind the printed cloths of this period was Iranian in character, similar to the floral decorative motifs of Mughal paintings. The processes used in the production, however, were similar to the process employed by the Kalahasti craftsmen. Pressure on the craftsmen to produce for the market made them move away from the slow hand-drawn technique of the Kalahasti style, and resort to block-printing methods for quicker results. Persian craftsmen were invited to the court of the Sultan, and many Iranian designs were introduced into the craft at this time (*Plate 51*). Stenciling of patterns with punched design sheets was the usual method for reproduction of these motifs. The Kalamkari craftsmen would use their pen for further embellishment of the patterns, with finer details. Thus the Masulipatnam style in the early period was a combination of stencilled design and freehand drawing. Later, with the advent of wooden blocks, the Kalamkari craftsmen was able to produce huge tapestries to order, putting the block prints together in a variety of ways.

The 'Tree of Life' was a favourite motif of this style (*Plate 52*). This decorative motif was used for wall hangings,

for prayer mats, and curtains. The *stambha*, the *pandu*, the *mihrab*, the cypress tree, and the paisley, which were the design elements of the Persian and Iranian art heritage, were introduced into the Kalamkari craft, taking on a new *avatar*. Individuality of the Indian craftsmen was evident in the interesting manner he put these foreign elements together to produce a tapestry which was fully Indian in character.

The block-printed Kalamkari tradition of Masulipatnam is categorised as the mosaic inlay tradition, because it is very similar to the patterns and designs found in the marble inlay work seen on Mughal architecture. The earlier tradition of temple Kalamkari is known as the earth tradition because of the dark earth colours that were used. Even though these two traditions are different in style and application, the basic technique of using the *kalam* for detailed work and vegetable dyes for colours is the same.

Figurative drawings, other than religious, were also produced in the Kalahasti style during this period to celebrate special events, or as painted scrolls to gift on social and political occasions. The Kalamkari painting reproduced here *(Plate 53)* is taken from the Victoria and Albert Museum, London. It was probably painted to commemorate a special visit, or mark the signing of a treaty, for it shows Indian nobles in the large frame, and foreign gentlemen and ladies in the smaller panel below. Panels showing various articles, probably gifts, are also shown. This is from the Golconda region and is a valid representative of the secular trend in the painting style.

By the end of the 16th century, Kalamkari fabrics had penetrated the markets of the West. The beauty of these light cotton fabrics in beautiful colours caught the attention of the Western fashion trade. French, Dutch and English merchants had started trading in these printed fabrics, even during the

Muslim period. Later, under British rule, trade in Indian chintz, as categorised by the English merchants, grew in volume and importance. Many new designs were introduced into the craft at this time. The English had entered this market as merchant traders concerned purely with business. They had their own ideas about what would or would not sell. Pressure was put on Indian craftsmen to produce according to specifications, incorporating designs, which they thought would be saleable. New elements of designs, which were English in character, like the Tudor rose, poppies and other English wild flowers, shepherds and shepherdesses, Grecian urns and similar Western design elements, now crept into the Kalamkari textiles *(Plate 54)*.

The 'Tree of Life' motif, still remained popular for use in curtains, bedspreads, etc. but a different look was given by introducing English designs on the borders and embellishments inside the main frame. One of the business letters, written to the East India Company from London, reflects the anxiety of the English merchants to produce designs to order. One letter states: "Note this for a constant and general rule, that you change the fashions and flowers as much as you can for the English ladies..." Another letter states vehemently "...the craftsmen must be forced to work to the perfection of the pattern."

Changes in design and variety were brought about by introducing new design elements, for which a profusion of paper designs and tracings, embroidery patterns, wallpaper designs, even marquetry designs were sent to the Indian craftsmen, culled out of a hotch-potch of design sources *(Plate 55)*. Constantly threatened and under pressure, the poor craftsman incorporated these foreign elements, as best as he could, with sometimes ludicrous effect.

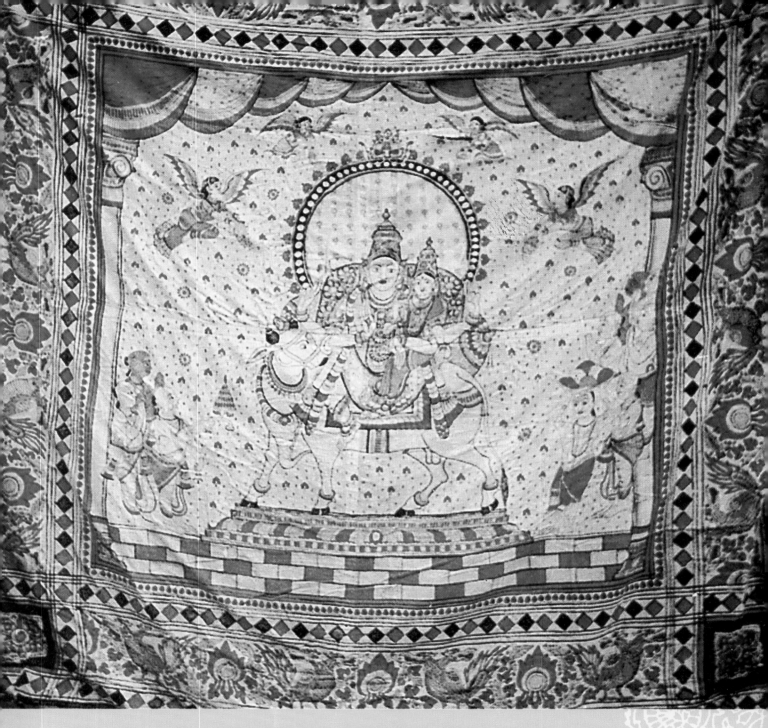

Plate 47: 'Rishabha *vahanamoorti*' —— Shiva and Parvati on the divine bull. Flooring with flying *kinnaras* show impress of Bijapur and Persian influence on design.

Kalamkari by its very nature was not suited for fast and bulk production. Even with printing blocks to speed up the process, Indian craftsmen loved to linger on freehand embellishments, which was inherent in his nature. This leisurely, casual approach to production often drove the British to distraction. Shortcuts were invented to speed up the process, and introduce new elements in the existing framework of the design, to make it look different. One method frequently adopted was to retain the central motif, which could be stencilled in vast numbers. The finer details were attached later, with variations in the foliage, flowers, and animal forms. Even designs from face doilies were also introduced to bring variety to the borders *(Plate 56)*. Kalamkari chintz therefore, moved away from the earlier traditional designs, both Hindu and Mughal. The British East India Company traders were interested more in the quantity produced than in the quality of design. Unfortunately, no designers or textile experts were involved in the production, as it was solely in the hands of merchant traders.

It is remarkable that the Kalamkari art survived such brutal assault and vandalism. The reason was the inherent beauty of its colours and the instinctive craftsmanship of the Kalamkari painter who produced out of this fissiparous lot, a pleasing whole — perhaps a little quaint, but still beautiful. Over the centuries, the Kalamkari tradition thus slowly moved away from being an exclusive, fully hand-painted art form, and was transformed into a commercial commodity, shaped by the exigencies of trade. This trend unfortunately, continues even to this day. The soul of the craft has been gradually drained out, leaving behind the shell of mere technique.

Plate 48: Traditional artist Radhakrishna Naidu points out details of tapestry illustrating the marriage of Lord Subrahmanya and Devyani.

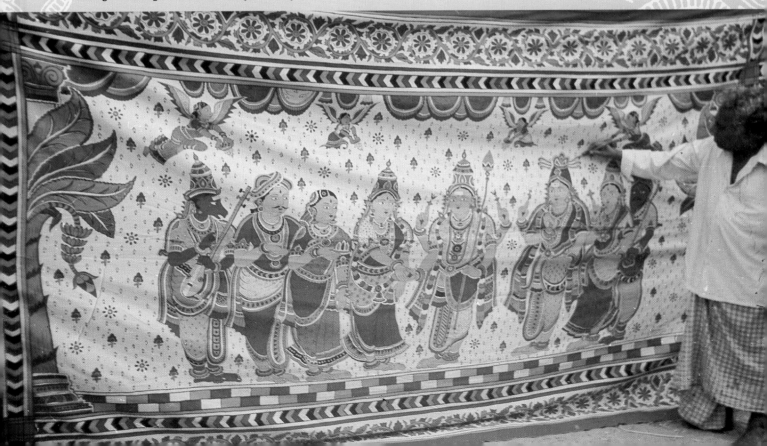

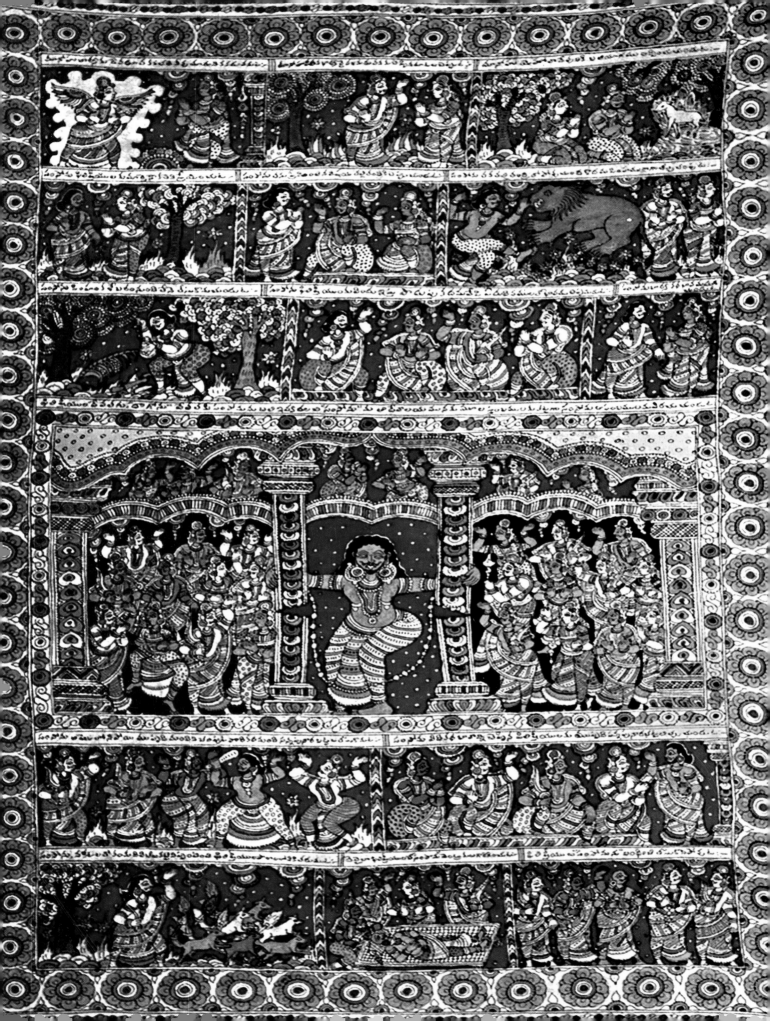

Plate 50: A Kalamkari panel different to the usual religious topics. This painting is by artist N. Harinath.

It illustrates a story from the Sanskrit classic *Panchatantra*. Attributed to AD 500, the *Panchatantra* is similar to *Aesop's Fables*, imparting worldly wisdom through animal stories.

In the story illustrated here, a woodcutter befriends a lion in the forest by sharing his food with it. This friendship is subverted by the lion's animal friends, a jackal and a crow. The lion turns on the woodcutter and tries to kill him. He, however, escapes by climbing and hiding in a tree. The moral of the story is that even good persons can be led to evil deeds by wicked friends.

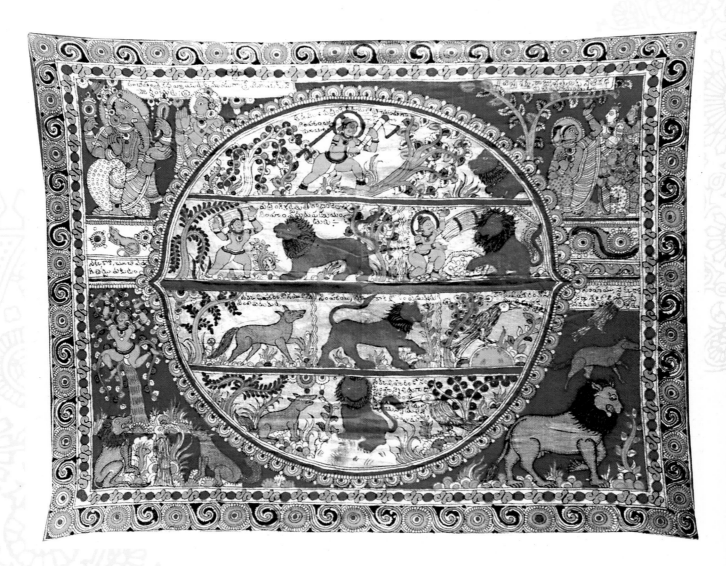

Plate 49: SAMSON AND DELILAH from the Old Testament of the Bible. A Kalamkari religious tapestry on a Christian theme, painted by artist C. Prabhakar. The legend is written in Telugu script (facing page).

In accordance with Kalamkari convention the centre large panel illustrates the main theme: Samson's supernatural strength and the vanquishment of the Philistines. The upper panels illustrate the story of his birth starting with the figure of an angel appearing before Menoah's wife and predicting that a son would be born to her who would deliver Israel from the Philistines. He, however, falls in love and marries a Philistine girl. The subsequent events, as recounted in the Bible, are illustrated. The treachery of his wife Delilah who learns the secret of his strength lay in his hair, and his capture by the Philistine soldiers who cut his hair and tie him to the pillar of their temple are illustrated in the bottom panels. Samson prays to Jehovah and with regained strength he breaks the pillar to which he is tied, killing the Philistines.

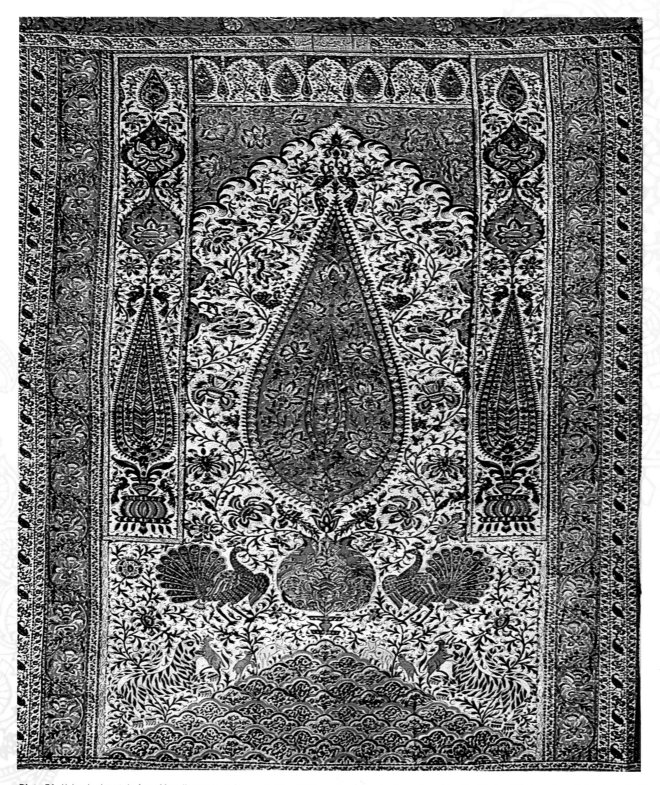

Plate 51: Kalamkari curtain from Masulipatnam region, probably of 18th century, showing incursion of Iranian block prints (*courtesy*: Kalakshetra Archives).

Plate 52: 'Tree of Life' design in Masulipatnam style (*courtesy*: *Berlin Handbook of Indian Art),* (facing page).

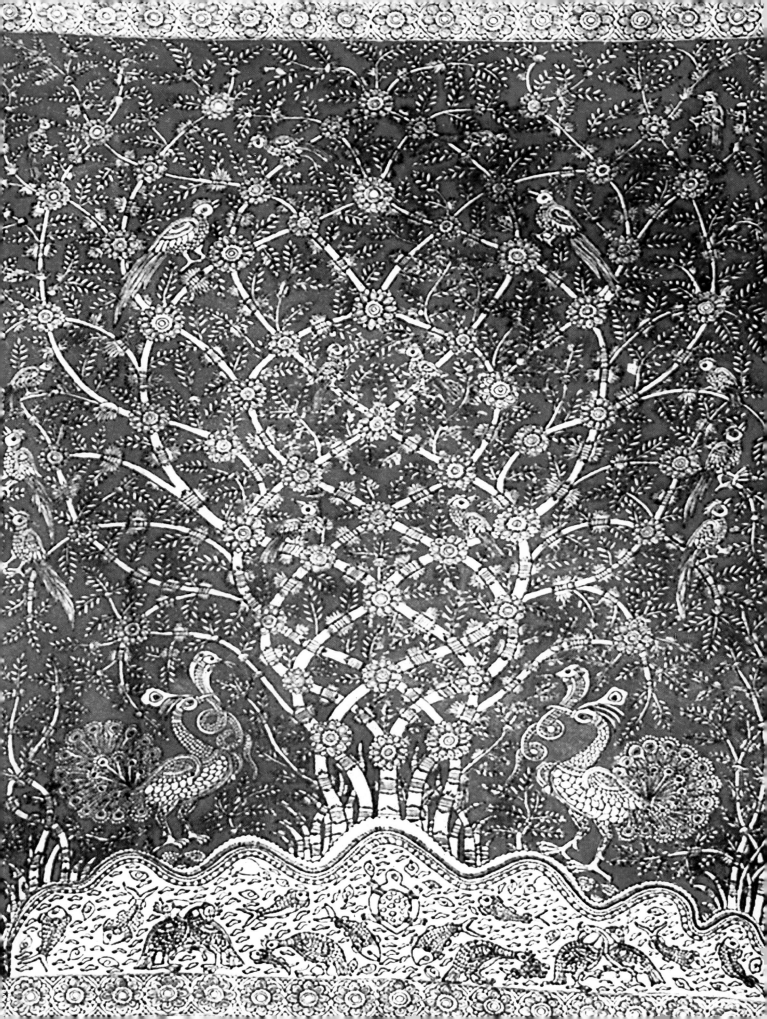

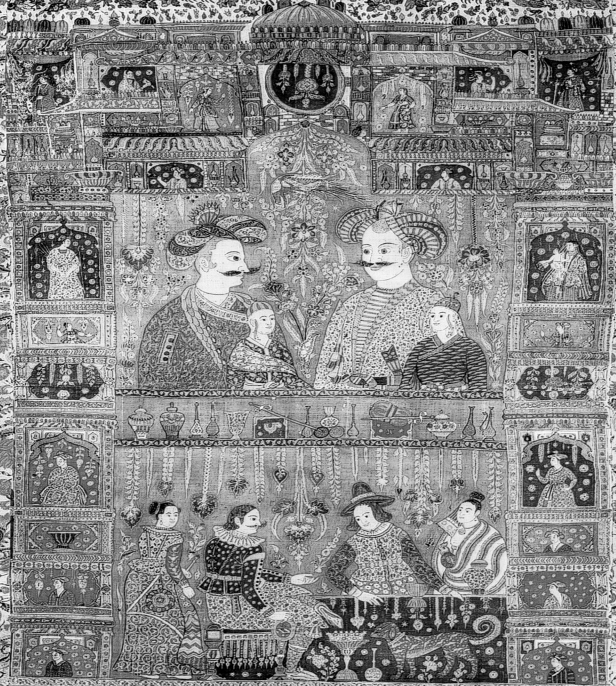

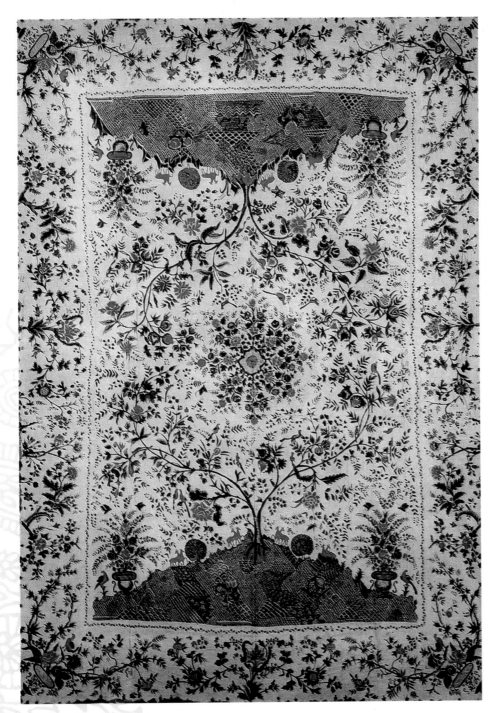

Plate 54: Printed and painted Kalamkari bedspread for the British market, showing British influence on the Kalamkari craft (*courtesy*: *Origins of Chintz*).

Plate 53: Hand-painted Kalamkari tapestry from the Golconda region attributed to the 17th century (*courtesy*: Victoria & Albert Museum, London), (facing page).

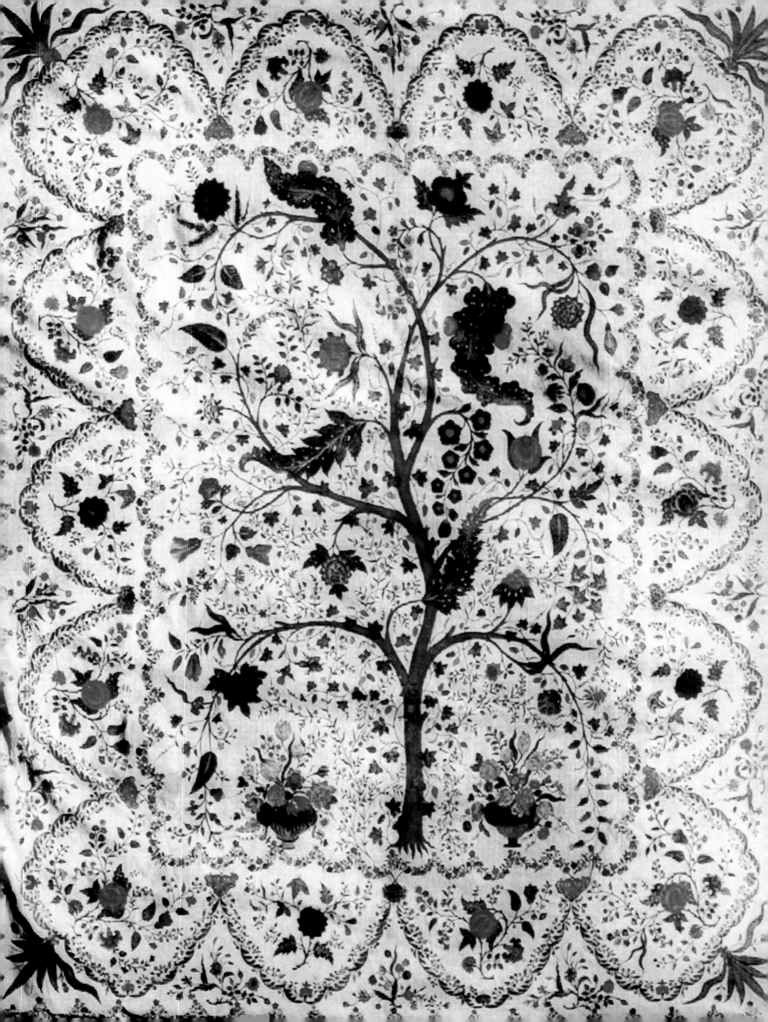

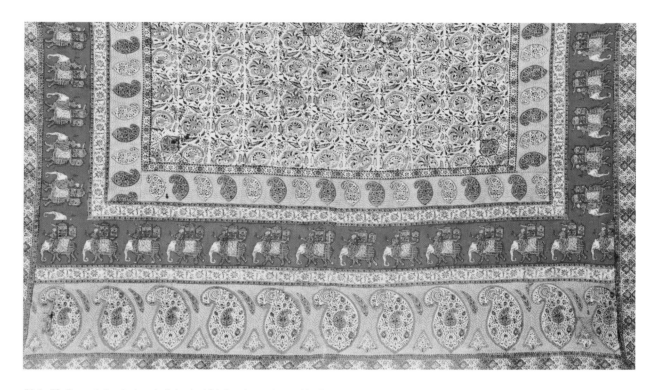

Plate 56: Present-day designs in Kalamkari fabrics show a happy blend of Hindu and Islamic traditions. Illustrated below is a Kalamkari bedspread from Masulipatnam (*courtesy:* Government Museum, Chennai).

Plate 55: A 'Tree of Life' design in the British mode (facing page). This Kalamkari curtain made in Masulipatnam is fully English in character with lace doily design on border, flower vases and other flower and leaf designs which are taken from embroidery patterns (*courtesy: Origins of Chintz*).

Design Vocabulary

Kalamkari is primarily an art of the pen and it is the freehand line drawn with the *kalam*, that forms the base of Kalamkari design. Strongly linear and two-dimensional, it represents the formal qualities of traditional Indian art with emphasis on surface design and simplification and abstraction of the form *(Plate 57)*. There is no shading or an attempt at perspective. In this aspect, perhaps, this ancient Indian art can be termed avant garde for modern painting also debunks realism, reducing objects to their essential form, which is sometimes distorted to convey a mood. Similarly, the Kalamkari artist conveys *rasa* (feeling) through emphasis on certain elements in the design and manipulation of form. The *mooshika* in the old Kalamkari tapestry thus conveys the mouseness and not a real mouse, and its Divine character as a vehicle of Lord Ganesa is brought out by the size and power of its form. Similarly in the drawing of 'Viswaroopam', the divine purpose is revealed by the cosmic form of Sri Krishna. The entire human situation, the drama being played out in the battle-field of Kurukshetra, is put into a correct perspective, so that Arjuna can do what has to be done, without suffering from guilt at having to kill his own kinsmen.

Like the Ajanta frescoes, Kalamkari art reveals a penchant for religion in its choice of subject, but unlike the passiveness of Buddhist religion, these paintings are full of the restless energy of the Hindu pantheon. In the six-fold classification *(shadanga)* of Indian painting, the

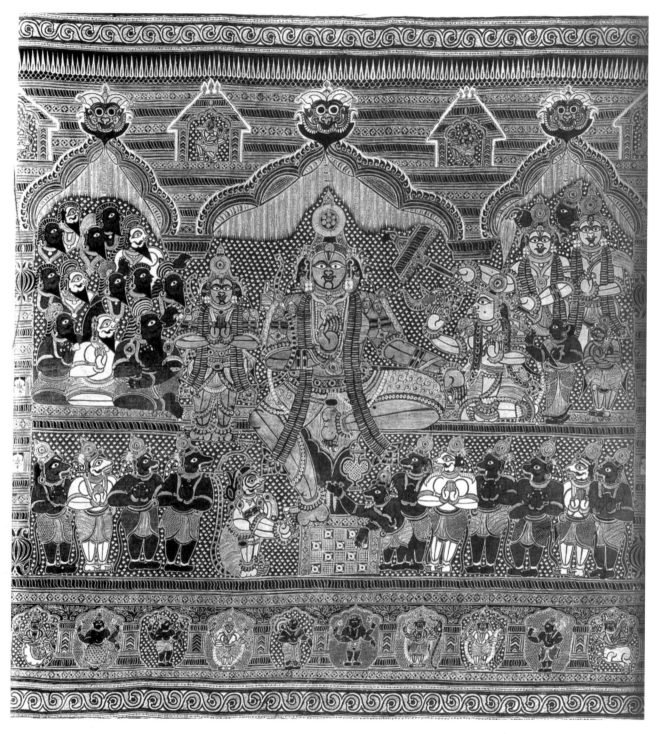

component of *bhava* (expression of feeling) in the form, and *lavanya yojana* (addition of grace and beauty) in artistic presentation, are considered more important than realism and fidelity (*Plates 58, 59, 60* and *61*). *Sadrisya* (realism), one of

Plate 57: 'Rama Durbar', a Kalamkari painting from Tanjore region (*courtesy*: National Museum, New Delhi).

the six components mentioned, is described as perceived realism and not as an actual representation.

Another important aspect is *varnikabhanga,* which means perfection of the technique or mastery over the implements and materials used in painting. In this aspect, the Kalamkari artist was supreme. The lines of the drawing flow with ease and spontaneity. There are no sharp bends, no awkward angles, no drawing twice over the lines in correction. The drawing is smooth flowing, and this mastery over line

conveys *bhava*, the mood, as naturally as the teller of tales, the village bard, conveys through his music. The function of the painting was to tell a story, and this it did without resorting to photographic realism, for the mood which it sought to convey was transcendental in nature. In order to convey the inner spirit, it was necessary to 'put down' the realism of perceived objects and enhance or exaggerate the other elements in the picture.

As a temple art closely linked to religious ritual, the paintings had a spiritual function. The 'shamanistic' nature of the painting made it necessary to resort to symbolism, which

Plate 58: Rama chases away demons who disturb the religious sacrifice being performed by Sage Viswamitra.

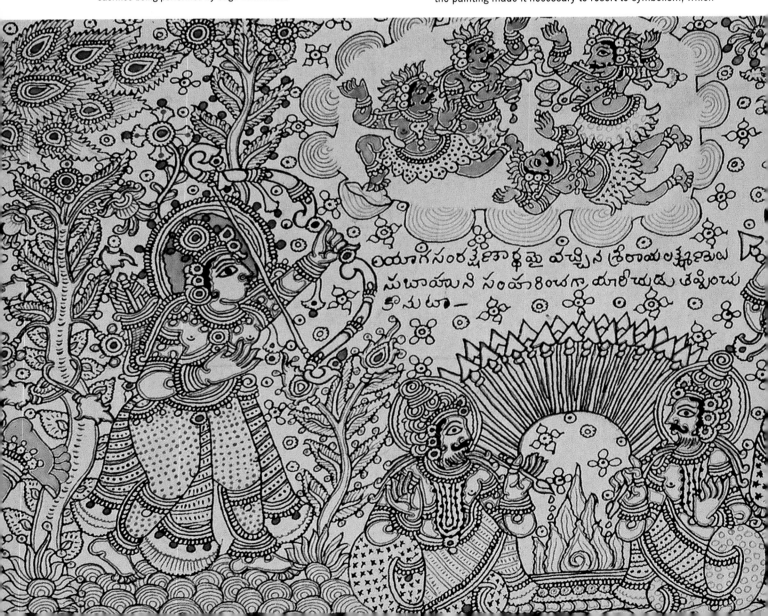

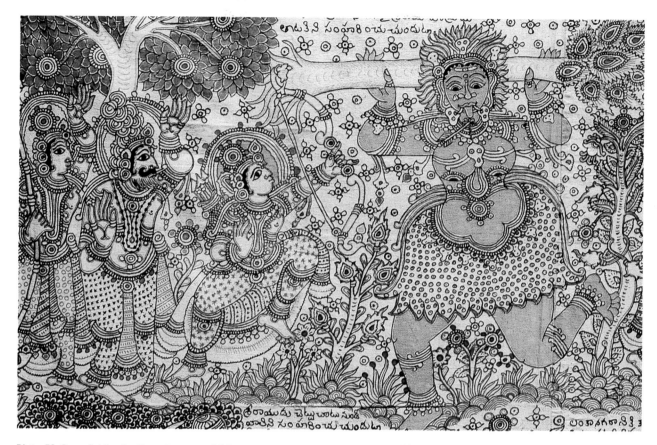

Plate 59: Rama fighting the fierce demoness, Tataka.

was part of Hindu religious iconography. The Kalamkari artist was well versed, not only in the stories of the epics, but also with the iconography of various gods and goddesses in the Hindu pantheon. The prescribed conventions of drawing Divine figures, religious literature, mythology and fable, the entire gamut of Indian culture went into the making of a Kalamkari artist. It was from his own mind and not from the real world that he drew the figures. The *sadrisya* (realism) was therefore fidelity to an inner figure, which he contemplated upon. In every large Kalamkari painting, the first panel always shows the artist in a contemplative mood of worship of Ganesh (the remover of obstacles) before he embarks on his project. The symbolic language of the paintings was indeed a mother tongue with which the viewer felt an instant rapport. There

was no need for any explanation. For the painter, the purpose of painting was the depiction of a mystic tale. As a teller of tales, he needed to have knowledge of the epics, like the *Ramayana*, the *Mahabharata*, or the *Bhagavata Purana*. Many of the episodes from the epics taken out and produced as short stories were the favourite themes. In this, the artist was helped by the language of symbols, which conveyed the thought without further elaboration. Just a lifted finger, a turn of the head, was sufficient to convey the emotion. Meaningful use of gesture of the hands, the *mudra*, to convey emotions was always considered as the most important aspect in the making of an image. The frescoes of Ajanta contain many beautiful examples of such 'speaking hands'.

Mudras, hand gestures, are well known in the Indian art tradition — be it dance, religious ritual, sculpture, or painting.

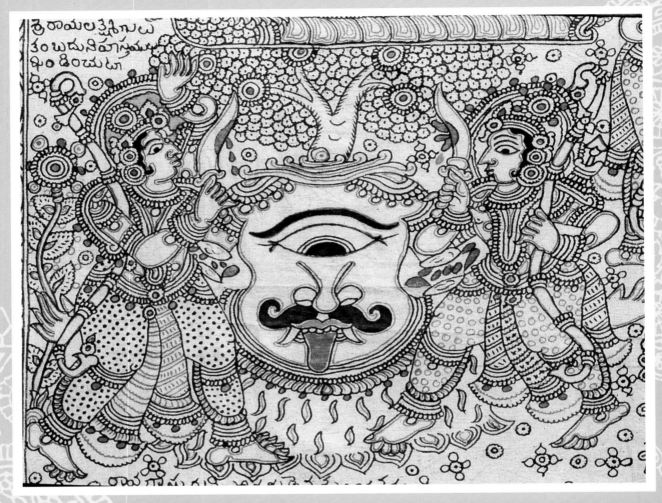

Plate 60: Rama and Lakshman cut off the hands of the fierce demon, Kabanda.

A raised palm signifies benediction, while the left hand, open palm, pointing downwards, signifies bestowal of blessings. The various gestures and other attributes of the divine figures had a meaning to convey. The *pasa* (noose) signifies attachment to worldly things. The *ankusa* (goad) is divine anger, which cuts us loose from worldly preoccupations. The conch of Vishnu signifies *sattvika ahankara* or ego, while the *chakra* (discus) denotes the mind. The *indriyas* (the senses) are depicted by the arrows he carries in his hand.

Describing Lord Shiva's cosmic dance, a Tamil passage says, "Our Lord is the dancer, who, like the heat which is latent in firewood, diffuses his power in mind and matter, and makes them dance in turn." Shiva's dance is said to symbolise the fivefold activities of creation, preservation, destruction, illusion and liberation. Creation is symbolised by the drum, which is shown in one hand, while the fire, carried in the other hand, denotes destruction. The lifted foot grants salvation, and with the other foot he crushes *apasmara,* the demon of ignorance. Each divinity in Hindu iconography has a similar deep metaphysical significance.

Of the six attributes of painting, *varnikabhanga* denotes mastery not only over technique, but also in the use of colours. Colour was also linked to an idea and was used with effect to convey the mood. The red colour denoted *rajas* (violent emotion)

and is therefore used in painting the figure of Ravana. White and yellow, on the other hand, were *sattvic* in nature and thus denoted nobility and godliness in character. Blue was the colour of Vishnu and of all his *avatars* like Rama, Krishna and others. Some of the *sattvic* godly figures were painted green, which was a combination of blue and yellow. Black, *tamasic* in nature, was used to depict figures of the nether world as also the ungodly *rakshasas* and *rakshasis* (male and female demons). Colour thus followed the demands of *bhava* and was used with care so that a feeling of harmony was conveyed through the paintings *(Plates 59 to 61*: Sections of Kalamkari paintings by artist Muniratnamma, in author's collection).

Plate 61: Hanuman kills Lankini, the demoness who guards Lanka.

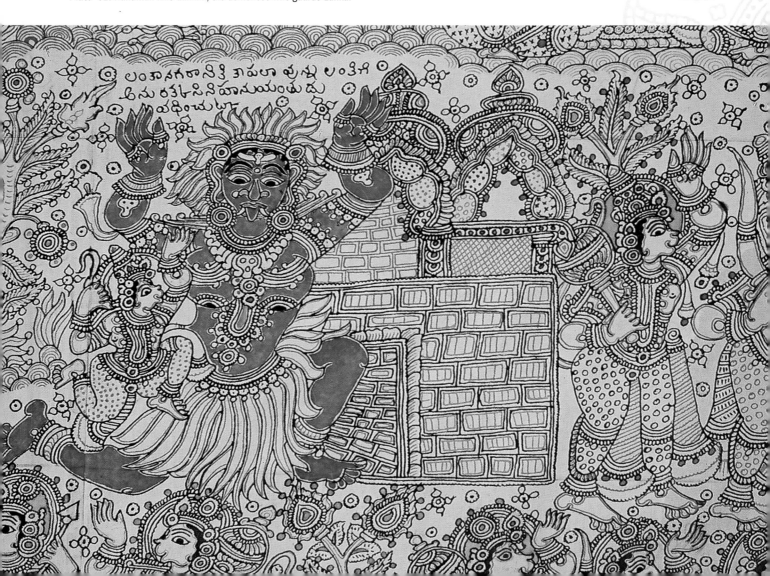

Plate 62

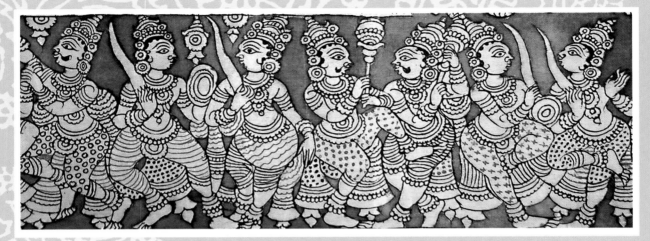

Plates 62, 63 and 64: Sections from a huge Kalamkari tapestry titled 'Yama Durbar' by Kalamkari artist, Muni Raghavulu.

Yama, Lord of Death, with his wife is shown going in procession riding on the bull. This centre panel is surrounded by panels showing his retinue carrying various weapons of war (author's collection).

Plate 63

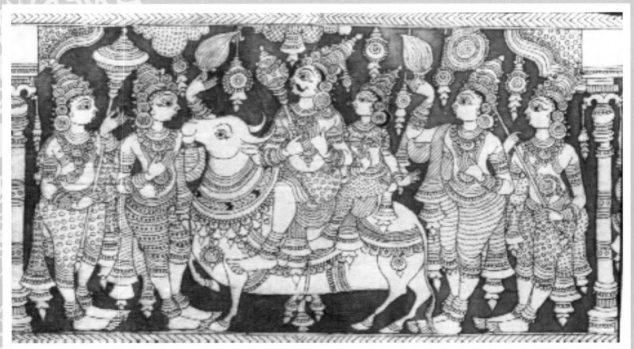

Government Kalamkari Training Institute, have learnt the technique, but it is only a few who have imbibed the spirit of the craft and emerged as true artists.

These artists are commissioned by other establishments who take the sketch and complete the painting by drawing the *kaseem* outline

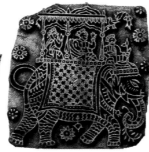

Plate 71: Five-piece elephant block.

and then developing the colours. Craftsmen who do these operations as jobbers are paid fixed rates for each operation. Labour charges for the painting of the outline with *kaseem* is Rs 50 per metre, and for application of colour (yellow, blue or alum) is Rs 15 per metre. Similarly, Rs 10 per metre is charged for boiling in the vat and subsequent bleaching operations cost Rs 10 per metre. In the co-operative society therefore, many of the operations are carried out by semi-skilled craftsmen who earn a meagre living out of these peripheral activities.

There are also some women who are daughters of master craftsmen and who have emerged as competent artists. The beautiful *Ramayana* painting illustrated (*see Plates 58, 59, 60 and 61*) was crafted by Munirathnamma, daughter of master craftsmen, Muni Reddy, who is no more. Munirathnamma, who is married, carries on the tradition by working out of her house. She produces beautiful tapestries on her own and also provides pencil sketches for the less-talented craftsmen who purchase the line drawings and finish it in their own way. She has received the state award for excellence in Kalamkari painting.

An outline sketch fetches on an average Rs 300 to Rs 600 per drawing, depending on the size. Ramachandra Mudaliar, an excellent craftsman, whose paintings are reproduced here, is in great demand among the Kalamkari fraternity for his pencil drawings. He earns Rs 650 per sketch.

A Kalamkari artist needs to have a sound knowledge of religious texts and mythological stories, which form the source material for his paintings. A deep spiritual approach and reverence for the subject endow the painting with rare beauty and an aura of mysticism, which mere technical skill often lacks.

Such deep religious fervour and great skill is evident in the painting 'Viswaroopa Darshan' (see *Plate 1*), which forms the frontispiece. C. Mohan, the artist who painted this beautiful tapestry, belongs to the Idiga cate — a backward caste of toddy-tappers. Mohan's love for the art brought him into the fold of the Kalamkari Training Institute in Kalahasti and he is now a member of the Kalamkari Co-operative Society. The Kalamkari technique of painting on cloth with dyes which tend to spread, is a very difficult medium to handle for detailed work.

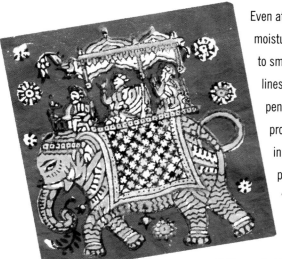

Plate 72: A Kalamkari block of an elephant.

Even atmospheric moisture often leads to smudging of the lines. The fine penmanship and profusion of detail in the Kalamkari painting, 'Viswaroopam', reflects not only the artist's great skill and command of the medium, but also his devotion and spiritual involvement in the making of the picture.

In the *Bhagavad Gita*, the 'Viswaroopam of the Lord' is described in great detail: "There, in the body of the God of gods, the son of Pandu saw the whole universe resting in One with its manifold divisions. He saw the yogic form of Maha Vishnu with numerous celestial weapons uplifted in his hands, wearing numerous garlands and celestial ornaments and he also saw all the *devas*, Brahma seated on the lotus, all the *rishis* and celestial serpents, and seeing the Divine form filling the entire space between heaven and earth, he was overcome with fear."

It is remarkable that a simple craftsman without knowledge of the scriptures could visualise and give expression to this supernatural figure in the painting. It confirms the view that true art comes only out of deep spiritual experience and an inner perception which has nothing to do with mere technique. It is this inner vision that distinguishes a true artist and sets him apart from the rest.

Even for skilled craftsmen, however, Kalamkari does not provide an adequate wage and many of them earn on an average only Rs 3,000 to Rs 5,000 per month. Except for a few who have developed "contacts" and are able to market their paintings at fancy prices, the majority of craftsmen sell the paintings to the Andhra Pradesh Government Co-operative Society called Lepakshi. Paintings are purchased by the government emporium on a fixed price of Rs 300 or 350 per metre. A priceless work of art is thus reduced to the level of piece goods, and it is not surprising that craftsmen are forced to produce in quantity, with the resultant quality suffering. A good Kalamkari piece is entirely drawn by hand, and requires detailed embellishment. The craftsman cannot produce more than two or three pictures of approximately 2 metres each per month, if paintings of exceptional quality are to be produced.

Many craftsmen are able to survive only due to other extenuating circumstances. Prabhakar, a traditional craftsman, gets free living quarters in the compound of a Christian mission. Belonging to the Naidu community, his father married a Christian and got converted to Christianity. Apart from living quarters, the income from Kalamkari painting is hardly enough to cover the expenses of Prabhakar's household. His son is in college now, aiming for a better career.

Ramachandra Mudaliar is another very skilled artist whose sketches are in great demand within the community. He does all the operations connected with painting himself with the help of his wife. But even he hardly manages to earn Rs 5,000 per month.

A few artists belonging to the Reddy community have either some landed property or agricultural income with which they are able to make their ends meet. The community, on the whole, however, is economically backward.

In spite of the low input, the craft continues to be non-profitable, barely providing a living wage to the Kalamkari craftsmen. As already mentioned, there is no designing involved in the production of either hand-painted or block-printed Kalamkari, and the craftsmen just put together whatever is on hand without regard to its sale value or marketability. In the year 1991, a co-operative of sorts was set-up in Kalahasti, known as the Sri Kalahasti Kalamkari Kalarula Sangam *(Plate 68)*. This was the first attempt to form a group of about 50 craftsmen to produce Kalamkari fabrics as a joint venture. They were given a house to operate from by the local Panchayat. There are now three or four co-operatives funded by the local industries.

The water of River Swarnamukhi in Sri Kalahasti is regarded as excellent for developing the colours. Most Kalamkari operations are carried out in the open, especially on the river-bed, which is the atelier of most artists *(Plates 69, a, b, and c)*. The craft requires plenty of flowing water and sunshine, and the Kalamkari craftsmen make full use of Nature's bounty. Shallow depressions are dug out on the river-bed and filled with water in which the paintings are spread out for bleaching. As the water evaporates in the strong sunlight, it is kept constantly wet by repeated sprinkling of water, until the background of the painting acquires the required clarity. Thus the sun, the river, and open air, all go into the production of these tapestries. Weather is the main component in the preparation of Kalamkari and operations come to a halt during the monsoons.

In the block-printing establishments in Masulipatnam also, operations come to a halt during the monsoon. Unlike

Kalahasti, Kalamkari operations here are carried out on a larger scale. There is a well-established network of job workers for carrying out peripheral jobs of bleaching, dunging and washing in the river. There are also subsidiary industries which support and are supported by the Kalamkari block-printing establishments. There are four or five major block-making establishments in the Masulipatnam and Krishna districts of Andhra Pradesh. Hand-carving of wooden blocks is well established and is carried out in independent units in neighbouring villages, like Pedana and Polavaram. Some Kalamkari establishments have their own block-makers and designs are made to their specifications in their own precincts, while being guarded as their exclusive property *(Plates 70, 71, 72, 73 and 74)*.

Plate 73: A Kalamkari design block.

The Kalamkari craft is deeply ritualistic in nature and the craftsmen are very conscious of the religious purpose of the paintings. Many superstitions surround the making of Kalamkari paintings. Special paintings are commissioned by village folk for certain religious festivals. Even though Kalamkari craftsmen belong to different castes, their involvement in such folk customs knits them together as one community. The making of certain paintings, like that of Gangamma is a ritual similar to that of Mata-ni-pachedi of Ahmedabad. People belonging to the Yadava caste get these figures painted by the Kalamkari artists and *poojas* are performed on a full-moon night. Similarly, another goddess, known as Mathamma, is worshipped by the Madigas of Andhra Pradesh. The Madiga caste traces its origin to the legendary hero, Kartaveerajuna.

Kartaveerajuna is a warrior-hero of an interesting legend which is part-historical and part-mythological.

P. T. Srinivasa Iyengar, in his exchaustive treatise, *History of the Tamils,* traces the background of the Kartaveerajuna story to a historical Aryan king who ruled south of the Vindhyas. Arjuna Karthaveera, he says, was a contemporary of Trayyaruna, grandfather of Harischandra, who lived about 30 generations before Rama of the *Ramayana.* He was a great conqueror and raised the Haihaya power. This Arjuna, or his sons, raided the hermitage of Jamadagni, the Bhargava *rishi,* killed him, and carried off his cattle. Jamadagni's son, Rama Jamadagnya, later called Parashurama, killed many Kartaveera Arjunas and Haihayas in retaliation.

The Madigas of Andhra Pradesh, who trace their roots to Kartaveerarjuna, perform a 10-day festival called thte Mathamma festival, held in Sri Kalashasti. In this, the figure of Goddess Mathamma is worshipped. There is an interesting story which surrounds the female deity Mathamma. She, the mother of Parashurama and known as Renuka Devi, was the wife of Maharishi Jamadagni. Such was her purity and chastity that she was able to fashion a pot with the wet mud on the riverside, and carry water in it back home. The story goes that one day, while she was bathing in the river, she saw reflected in the water an amorous Kinnara couple sporting overhead in the sky, and her austerity was disturbed. As a result, she was not able to fashion her usual pot to carry the water. When she came back and related this to her husband, he was enraged that she had allowed carnal desire to disturb her mind and called upon his son to kill her, which Parashurama immediately did without question. The *rishi* was so happy with this obedience that he granted him a boon. Parashurama then asked for his mother's life, and Jamadagni brought Renuka Devi back to life. The Madigas have provided another twist to this tale. Renuka Devi, who was beheaded by her son, did not get her own head back, but got that of another woman. This form is worshipped by them as Devi Mathamma. This festival is also conducted on a full-moon night, like that of Gangamma festival. The colourful procession of this festival passing just outside the premises of the Kalamkari Co-operative Society in Kalahasti, is illustrated here *(Plate 75)*.

Plate 74: Five-piece paisley design.

The Kalamkari artist is a queer mixture of tradition, superstition and outdated practices, trying to come to terms with a world which has grown and expanded far beyond his horizon. Living with one foot in the middle ages, he carries on his craft doggedly, with fatalistic unconcern despite the vastly changed circumstances of everyday life in the village.

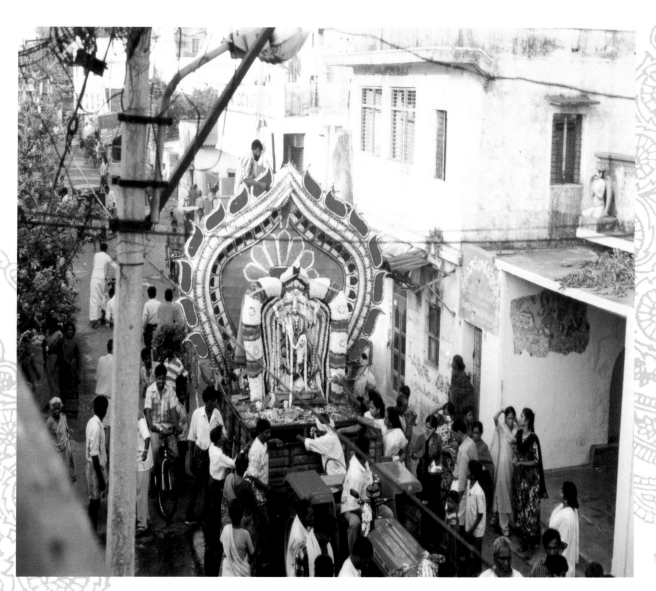

Plate 75: The Mathamma festival procession.

Colours from Nature

It is amazing that a 3,000-year old craft still survives, unaltered and majestic in its very simplicity. Absorbing various alien influences into its body fabric, the craft has however managed to retain its traditional identity and unique character. Kalamkari technique and tools have remained unaltered through the centuries and the present-day craftsmen have been able to survive only because they remain independent of market pressures by making themselves the tools and dyes required for the craft.

The strength of the craft is based on sound techniques, which have stood the test of time. Ancient practices in the extraction and fixing of colours are still followed by the craftsmen. Cloth used for Kalamkari painting is generally unbleached calico *(gada)*, which craftsmen prefer to bleach themselves. Sizing and impurities in the cloth are removed by soaking it in cow-dung, to which is added a milky liquid which is a crude kind of soap made by mixing washing-soda solution and castor oil. The cloth is kept in this solution for a whole night, taken out, washed in flowing water, and beaten well on stone, to make it soft and absorbent.

The next step is the 'galling' process. Myrobalam nut (which is rich in tannin) is ground to a paste and made into a solution with buffalo's milk. The fat content in the milk prevents the dye from spreading on the cloth, and it also forms a fatty base for better absorption of colours during dyeing. After galling, the cloth is beaten again and brushed to remove encrustations of the myrobalam powder, and to make it smooth.

In olden days, a thick wooden mallet, a cylindrical piece of wood from the tamarind tree, known as *kotapuli,* was used for this purpose. Manual beating with a smooth wood was considered essential to render the cloth smooth and absorbent. Only then was the cloth considered ready for painting.

Myrobalam, a popular herb in Indian medicine, is a valuable mordant and dye, crucial to the Kalamkari craft. Collected from a deciduous tree which grows all over India, ranging from the foothills of the Himalayas down to the hills and valleys of the Deccan plateau, the dried fruits of this tree constitute the chebulic and black myrobalam of commerce, one of the most valuable of Indian tanning materials. The fruit known as *kadukkai* is commonly used as a mordant in all vegetable dye processes.

The first step in painting is therefore the preparation of the canvas by soaking the cloth in a myrobalam-and-milk solution. In block-printing establishments, the milk is not considered necessary, for the designs are printed with solutions thickened with gum, but in the purely hand-painted Kalamkari of Sri Kalahasti, milk constitutes an essential component.

The design is sketched directly on the cloth with a charcoal stick, which is made by burning thin sticks of the tamarind tree. This forms a very soft pencil which slides smoothly over the cloth. It has also the added advantage of being easily washable during the process, unlike the present-day lead pencils, which leave traces difficult to erase. The craftsman is an inspired painter, and the pencil is used by him only for briefly sketching the layout, as he ruminates on his subject and

makes preliminary strokes on the cloth. The actual drawing starts with the *kalam,* which has given its name to this craft *(Plate 76).*

The craftsman sits on the floor with the cloth spread on a low table, about a foot high in front of him. The cloth is not fixed to the printed table, but is spread loosely and shifted form time to time as the painting proceeds and each portion gets completed.

Kalamkari is a conjoint of two words — *kalam* (pen) and *kari* (work). The *kalam* is a thin bamboo stick honed to a point at one end. Several *kalams* are made at a time with different points — thin, thick, blunt or sharp — which are as functional and efficient as the sophisticated and expensive drawing pencils and brushes used by modern artists. Above the pointed end of the stick, a reservoir for the dye is fashioned from scraps of an absorbent, loosely woven

Plate 76: *Kalams* and charcoal pencils.

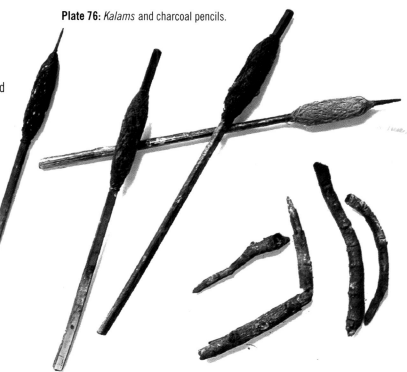

material tied into the shape of a bulb with cotton thread. The bulb absorbs the liquid and the craftsman directs and regulates the flow of the dye by holding it in his fingers and gently squeezing it as he draws.

The *kalam* thus becomes an extension of his fingers, creating life as it fills the blank canvas almost like a magic wand. The liquid medium of the dye imparts fluidity to the lines drawn. There is no messing about with thick pigments and binders and frequent stops to blend the palette. Unlike paint brushes, palette knives, or pencils, the *kalam* is not a stiff, unyielding instrument, but a soft sponge which provides an uninterrupted flow of the liquid medium for drawing.

The dye used for the black outline is an iron acetate liquor, known as *kaseem.* This is brewed in a mudpot by soaking scrap iron bits in a solution of palm-jaggery and water *(Plate 77)*. In olden days, fermentation was induced by adding toddy, a country-made liquor or by addition of gram flour. This is not considered essential nowadays and the fermentation is induced by using old jaggery. An experienced craftsman knows by the smell of the *kaseem* when it is ready. The foam formed on top is skimmed off and the liquor is filtered and transferred to another pot in which it is stored for painting. This liquid is applied directly by the *kalam* to the fabric. The iron acetate liquor gives a brown stain (like the rust stains one finds on clothes) when applied directly, but on myrobalam-treated cloth, it reacts to form an indelible black. This black is so strong that it does not fade even when the paintings are subjected to prolonged soaking and bleaching subsequently, which are part of the process.

While the black outline is painted directly on the cloth *(Plate 78)*, other colours are developed through a complicated process, in which the salt which binds the colour to cloth

Plate 77: Making the *kaseem* dye.

alone is painted or printed and later developed in the dye-bath. This is because vegetable dyes do not take easily to cloth, especially cotton, and require a mordant to fix them permanently to the cloth. The word 'mordant' is derived from the French word, *mordere*, meaning 'to bite'. The salt used as mordant is said to 'bite' into the fabric to bond the colour.

The mordant commonly used in Kalamkari is alum, known as *padikaram* in the southern districts and *phitkari* in the North. It is a common ingredient easily obtained from the country drug shops. So fascinated were the common people by the power of this crystalline white rock that they came to believe that it was endowed with magical properties. It is

often tied to the doorways of shops and residences to ward off the evil eye by absorbing inimical forces. This white mineral powder derived from bauxite is used as a fixative for all vegetable dyes. Craftsmen cherish its fixing powers so much that even after the entire process is completed, the painting is given a final bath in alum solution.

In the Kalamkari process, alum is powdered, made into a solution with water and then applied to those portions of the design which need to be coloured red. As can be seen in some designs, a red line is drawn inside the black. Red dots, stippling and hatching lines, are all drawn with the alum solution.

Approximately 100 grams of powdered alum are dissolved in about a litre of water, and this solution is applied by *kalam,* wherever the red colour is required. After application of the alum mordant, the cloth is rested, dried, and then washed in flowing water. The gentle flow of the river is considered best at this stage, for vigorous washing is not required, but only surface removal of excess alum, so that it does not flow into the other areas while dyeing, and cause smudging.

After washing and drying, the cloth is placed in the dye-bath for development of the red colour. The dye-bath is prepared with *manjishta* (madder), the red colouring vegetable matter, which is pulverised and added to the water.

Plate 78: Painting the outlines with black dye.

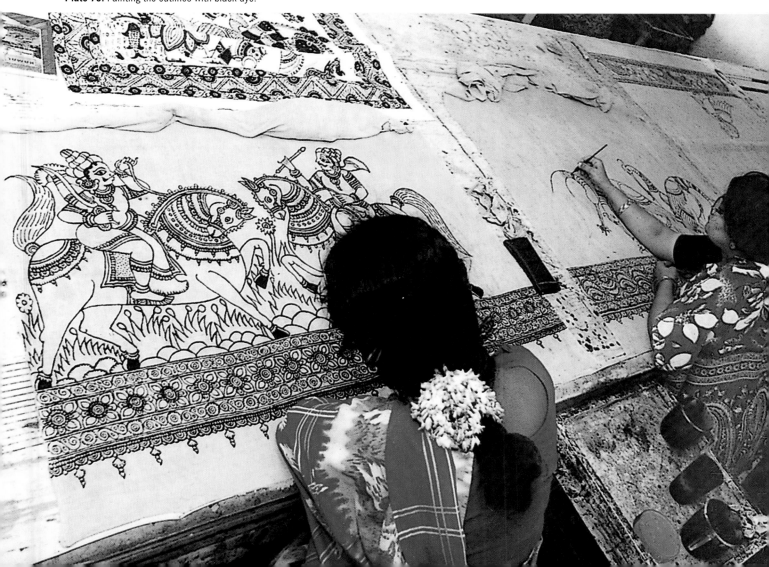

Vegetable surfactants like *probakku* or *jajjiyakku* are also added to ensure even dyeing. The red colour imparted by the madder root gets fixed only on those areas which were painted with alum. The rest of the cloth remains clear and even if it takes on a slight pink tone from the dye, it is a fugitive colour, which is subsequently bleached out.

Manjishta, which imparts the red colour, is known under various names, like *manjit, shevali kodi, manchetti,* etc. This herbaceous creeper grows in the hilly districts of India. The botanical name is *Rubia cordifolia* and the common name by which it is known throughout the world is 'madder'. In the memoirs of Emperor Babur, we read that madder was cultivated in Ghazni and in some European texts we find that it was cultivated as a cash crop in New Zealand by refugees from Flanders. Since red dyes were scarce in the vegetable kingdom and insect dyes were mostly used for this colour in the West, madder became a prized commodity. Turkey had a well-established commerce in madder and had perfected a special technique, known as the oiling process, which produced a distinctive shade of red in the wool used for carpets. This colour became popular as Turkey red and is known by that name even today.

In India, *manjishta* was one of the earliest dyes known and *Brihat Samhita* not only mentions this dye, but also the technique of mordanting with alum.

The beautiful deep red colour obtained from the roots of this plant is a valuable dye, which has been in existence for over 3,000 years. This is borne out by the fact that madder-dyed Indian fabrics have been discovered during excavations at Harappa. Madder-dyed cloth with the *hamsa* motif has also been found in Egyptian tombs at Al Fustat, near Cairo. The remarkable thing about these findings is that the colour red has not faded even after thousands of years. Indian madder, *manjishta,* has been central to the dye industry in India since very ancient times and we find detailed descriptions of its extraction and application in Sanskrit literature.

The technique of printing with a mordant prior to developing the colour in the dye-bath is peculiar to the Kalamkari craft. Unlike other painting and printing techniques, where the specified colour is applied directly, in Kalamkari, only the colourless salt is printed and the red design appears after boiling in the dye-bath containing the colouring herb. Even though the entire cloth is subjected to the dye, the colour gets fixed only to those portions which have been painted with alum. The rest of the material does not absorb the dye. A faint fugitive colour is imparted to the rest of the cloth which is subsequently removed by washing and bleaching in sunlight. This process does not affect the portions painted with alum and repeated washing makes the black and red brighter.

This tendency of the cloth to emerge brighter after washing was a source of wonder to the people from the West and it is not surprising that Indian chintzes came to be prized because of this quality.

Bleaching is done by exposing the painted cloth to sunlight. The painting is spread out on the river-bed on wet sand and kept soaked with frequent splashings of water. As the water evaporates, the action of sunlight bleaches the cloth. The turgidity of the background is bleached out and the painting takes on depth and clarity.

Red is the only colour that is developed by boiling in the vat. Another herb commonly known as *surulpattal,* which is a purplish-brown dye, is added with *manjishta* to deepen the red. Variations in red colour are brought about by such methods.

Colours like blue and yellow are cold applications. A beautiful dark blue is derived from indigo which is a vat dye. Indigo dye cakes are reduced by dissolving them in water containing *chunam,* calcium hydroxide and *pappad khar,* a naturally occurring sodium bicarbonate, and cooked *Cassia tora* seeds. The dye pot is buried in the earth to maintain a uniform warm temperature. Since indigo oxidises very quickly, the colour can be only dyed, and not block printed. In the Masulipatnam tradition, this is done as the last step in printing, after covering the areas not required to be blue with wax. In Sri Kalahasti, blue is used sparingly and indigo is therefore painted on with the *kalam.*

After development of red and blue, the cloth is once again given a myrobalam and milk dip and the yellow dye is applied with the *kalam.* This colour is obtained from the galls of the myrobalam which is known as *kadukka poo.* The *kadukka poo* solution is applied only with the *kalam,* even in printing establishments. Referred to as 'yellow writing', this work is done by jobbers.

There are many natural dyes which produce good yellow shades. The best known among these is the ubiquitous turmeric, which is very much part of Indian culture, finding application in food, cosmetics and medicine. Turmeric is also given ritual status, and constitutes an integral part of religious ceremonies.

Mango bark dust and leaves also impart a beautiful yellow colour. The mango is another cherished tree in India. The fruits are easily the favourite with innumerable varieties produced and marketed all over India. Considered a tree of divine origin, the leaves are often used to decorate one's house on ceremonial and festive occasions. An ancient yellow dye, known as *peori,* was made from the urine of a cow fed entirely on mango leaves. This gave such a strong colour that it was used for miniature paintings on ivory during the olden days.

Similarly, the skin of pomegranate is also a strong yellow dye rich in tannin, which is frequently used. Pomegranate is a fruit grown as a commercial crop on the hilly slopes of Jammu, Himachal Pradesh and Punjab. Apart from the skin, which is a good vegetable dye, the seed of the fruit (*anardana*) is marketed as a condiment and is used for cooking in North India.

Good, strong yellows are derived from a variety of vegetable sources. Dried flowers of the *dadup* tree, a familiar sight in plantations and on roadsides, is part of the Kalamkari palette, known as *moduga or murukkampoo.* It is used both for dyeing and painting to impart a pleasing yellow colour.

Most of the colouring materials used in the craft are rich in tannin and therefore make good permanent colours. Extract of catechu, known in native parlance as *kasikatti,* imparts a strong brown and chocolate shade. It is a strong dye used with mordants like copper sulphate and potassium dichromate.

The main colours used in Kalamkari now are *manjishta* and *surulpattai* for reds, myrobalam fruit and galls, pomegranate peel, mango bark dust, turmeric powder and flowers of the *dadup* for yellow colour, brown from catechu and blue from indigo. *Kaseem,* the mineral black, provides black for outlines and also for deepening other colours.

Among the vegetable dyes, the basic colours of black, red, and blue are the most prized. We have already seen the tremendous interest shown by nations of the world in procuring indigo from India. Indigo, for all its fame and value, is a lowly shrub grown in India in agricultural lands, as green

manure. In the South, it is known as *avuri*. Grown carelessly, this crop is not utilised for colour, but is ploughed into the soil for paddy growing. Only in certain parts of India is the plant grown for the dye. It is one of the oldest among Indian dyes, which finds mention in many old Sanskrit texts, like *Arthashastra* of Chanakaya (4th century BC). The Indigo plant is grown in many parts of Bengal, Madhya Pradesh, Rajasthan, Andhra and Karnataka for extracting the dye.

It is one of the few vegetable dyes which imparts a deep, dark blue, that is extremely fast to washing and light. The extraction of indigo dye from the plant material is rather cumbersome, involving many stages. The leaves of the plant are steeped in water and the slurry is processed and made into cakes. Indigo cakes, which come to the market as a ready-to-use dye, are reduced once again in huge vats of stone or terracotta into which the fabric is dipped cold and taken out to fix the dye. The colour develops in the presence of air through oxidation. Several immersions in the dye-vat are required for obtaining a deep, dark blue. We get variations in colour, thus ranging from a pale sky blue to a very dark navy blue.

Indigo dyeing is a cold process and does not require boiling or the use of mordants. However, because the colour is developed only through oxidation, it is not block printed like other colours. In some North Indian handcrafted textiles, indigo printing is now being attempted in places like Bhuj and Rajasthan. Only small pieces are printed at a time.

Even though the palette of the vegetable-dye craftsman is limited, he is able to produce a variety of shades by skilful use of mordants and introducing depth in colours by more than one application of the dye. Many of the mordants used in the vegetable-dye craft are natural minerals like alum, copper, chrome and iron. Apart from this, through long

experience, the craftsmen have identified shrubs which are noted for their organic chemical content. Often these shrubs, which grow wild on the roadside, are used along with the colouring herbs to provide the mineral components. Certain herbs are burnt and the ashes, which are rich in trace minerals, are used as potash, in the dye-bath. Well known among auxiliaries to the dyes is the *Cassia tora* plant, the seeds of which are used for reducing indigo. *Mullu keerai (Amaranthus spinosus)* is another common plant, which is collected and burnt for providing potash. Even for washing, a number of indigenous herbs are available, which are preferred to soap and water. Vegetable detergents like *shikakai* and *ritha* are used for washing vegetable-dyed and printed materials.

Some specific plants are used in the dye-pot for even dispersal of the dye. The Kalamkari craftsmen of Kalahasti use a reed, which grows in their area and is called *pobakku* (tamarix). Similarly, in the Masulipatnam area, dried leaves of the tree *(Memecylon edule)* known as *jajjiyakku,* are used as surfactant along with the dyes. *Dadri poo* or *Dhai phul (Woodfordia floribunda),* is also used as a dispersal agent in the dye-bath.

It is by these tried and tested natural methods that traditional craftsmen are able to enrich the colour palette of vegetable dyes. Traditional methods perfected by constant use and practice have made this vegetable craft hold its own against the onslaught of chemical dyes.

Another reason for the survival of age-old practices is the inherent love for tradition ingrained in the Indian people. Natural dyes continue to be used in India today, often as part of rituals on religious and social occasions. The ubiquitous turmeric is the yellow colouring preferred for colouring ceremonial garments throughout the length and breadth

of India. In the North, another pretty pink dye, derived from the *kusumba (Carthamus tinctorius)* is very much in evidence for dyeing turbans and gay shawls worn on festive occasions.

People have always loved colour. Any colour that could be used to colour and pattern their garments was therefore a prized commodity. In ancient times, before the advent of chemical dyes, a colour-fast dye like indigo was therefore greatly valued and the world demand for this product far exceeded production. It derives its name from India (Latin *indicum* means 'from India'), which was the prime supplier of this coveted colour. It was a major item of Indian exports of the Middle Ages, literally 'launching a thousand ships', like the fabled Helen of Troy.

It seems unbelievable that wars could be fought and laws enforced for the sake of protecting indigenous dyes, but such was the reality in olden days when colouring matters were few and had to be obtained only from natural sources. Black dye obtained from logwood on the Campeachy Bay in South America was so popular a colour in the West, that British privateers used to cruise the Spanish Main to capture logwood cargo. Tyrian purple was another natural dye so greatly prized that it was reserved for use only by royalty. It was obtained from a shellfish caught along the Mediterranean coast and it is said that it required enormous quantities of the fish to obtain the dye. It was therefore, very expensive and the common people were prohibited by law to wear garments dyed in this rich colour.

Colour has also been responsible for the naming of some tribes. The Red Indians of America, it is said, were so-called because they coloured their skin a bright orange red with the Annatto dye. This orange due is still in use in modern times for colouring foodstuffs and finds limited application in textile dyeing also.

There are innumerable instances where colours have been central to cultures and to the prosperity of nations. India with its moderate climate and a variety of soil and water, has been a treasure-house of thousands of varieties of plants from which colours were extracted and used since very ancient times. Sanskrit texts mention the existence of a well-established dye industry with plants grown specifically for producing dyes. Of the 300 varieties that were known and used in ancient India, only a dozen are now in use.

Many dyes obtained from natural sources are still used, but their application in patterning of textiles is limited. Each region in India has its own palette of dyes, based on local plants and regional practices. Colours that have withstood the ravages of time have proved their validity by their very existence in the face of the onslaught of chemical dyes. They are still around because they have become an intrinsic part of village life, are easily available to the craftsmen, and are inexpensive.

Craftsmen continue to use such herbs out of habit and tradition. The subtle shades of vegetables dyes impart a distinctive quality to Kalamkari paintings. A craft rooted in Nature, Kalamkari tapestries evolved in harmony with the elements — open air, sunlight and flowing water. They thus carry the iridescent colours of Nature within them which endow the paintings with a unique character and beauty.

Future of an Ancient Art

The Kalamkari craft carried on and shaped by village artisans as a living tradition is now in a process of disintegration. An ancient heritage, over 3,000 years old, which had been central to great social and historical changes in the country of its origin, has been discarded and relegated to the dust-heap. It is indeed in dusty piles that Kalamkari paintings can now be discovered in various government emporia. Produced in their hundreds, in garish colours and designs, it is not surprising that this art fails to catch the attention of the discerning buyer. The soul of the art is dead, leaving only the empty shell of an art form, which was once vibrant with life and beauty.

Over the years, lack of demand and changing social patterns have eroded the Kalamkari craft structure so much that by the middle of the 20th century, there were hardly five families left practicing the craft. With the intervention of the Handicrafts Board under the leadership of Kamaladevi Chattopadhyaya, a few surviving practitioners of the craft were traced and a training centre for Kalamkari was started in Sri Kalahasti. With this timely revival, the craft was saved from total extinction. The problems which led to the downfall, however, still remain.

In olden days, craftsmen with a firm foundation in technique and eye for form, had an instinctive knowledge and approach to design. The beauty of ancient Kalamkari tapestries, faded and old, but still vibrant with feeling, are able to reach out to us, even now, in the midst of a

Plate 79: 'World Cup Soccer 1990' mascot depicted in Kalamkari.

Plates 80,81 and 82: Samples of Kalamkari black prints from the Kalamkari unit of Kalakshetra.

changing culture. They are beautiful because they are true to themselves. There is no artificiality, no copying, and no attempt to commercialise the art to cater to the market. History shows how this instinctive sense for beauty, form and colour of the Kalamkari craftsmen got gradually eroded by the pressure of foreign trade compulsions. By the 18th and 19th centuries, Kalamkari craftsmen had sunk so low that they had started reaching out to European wallpaper designs on which to base their art. In the two centuries of cultural hotch-potch, towards the end of the last millennium, the inherent artistic instincts of the traditional craftsmen has been totally destroyed. In present times, governmental agencies, with even less perception than the British administrators of yesteryears, commission Kalamkari artworks with a misguided sense of promoting traditional arts, which only highlights the decadence, as seen in the example given here *(Plate 79)*.

At the Lahore Art Conference in 1894, the Government of India drew the attention of the government of Madras to the following: "In all places at which there are distinct local industries, small museums or more correctly, showrooms, should be established, in which types of collections, illustrative of these industries, should be placed and kept up."

In his address, Lt. Colonel T.H. Hendley said, "It is for us gentlemen to ascertain whether it is possible to try to teach both purchasers and producers to differentiate the good from the bad, and if we cannot directly guide the dealers, at all events to see that our art schools and our museums only supply and purchase the best examples and do all they can to discourage the sale of indifferent ones."

The decline had started even during the 19th century as this report indicates and even after Independence, this has been neither perceived nor understood.

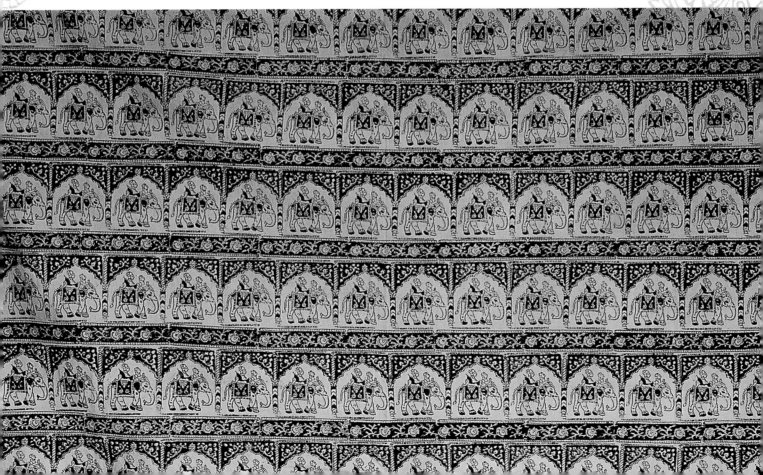

A proper perception, *divya chakshu,* is needed to understand the inherent nature of the craft and free it from the restraints that have been responsible for its decline. The first drawback has been the erosion of technique. It is unfortunate that traditional craftsmen have lost faith in their own heritage and are led astray by the glitter of the present-day textile market. There is a craze to be modern and introduce new colours to keep up with the changing social patterns. They copy new designs, which are bizarre and totally out of character, and use chemical dyes for easier production. Even while using chemical dyes, only the cheap, direct ones are often used. Locally available vegetable dyes are no longer employed in the craft. A chemical formulation, like alizarine, has become established for producing the red colour.

Similarly, natural indigo is not used at all. Instead a chemical powder, termed German blue, is used for the blue

Plate 83: Kalamkari vegetable block print.

colour. While dyes derived from natural sources blend beautifully together, chemical colours are jarring, and the painting loses its aesthetic appeal. This has led to a glut of unsaleable goods. There is no agency for proper designing, nor market-oriented selling. Craftsmen often sell their own products, individually hawking their products in the streets of Chennai.

The strength of the craft has always been its colour; colours derived from Nature, which had the world markets begging for more during the olden days. This is also a weakness, for the craft will continue to be limited and circumscribed by the availability of its raw materials. This is one of the reasons why the craft started dying down, when it was made to produce in vast quantities to meet the world demand. It may seem ridiculous in this day and age to crush roots and berries in order to obtain colour, but many similar traditional practices have proved their validity as

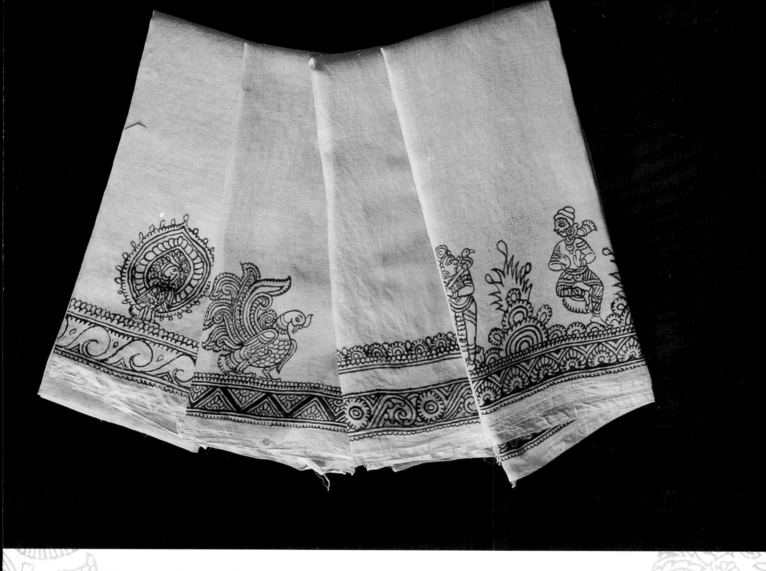

Plate 84: Kalamari hand-painted towels (Kalakshetra).

cottage crafts. Mahatma Gandhi had asserted, time and again, that India lived in its villages. The Kalamkari craft, strongly village-oriented and rooted in Nature — the sun, open air, and flowing water, is ideally suited to be developed as a cottage industry.

Kalamkari is a village craft, and it cannot be transformed by some magic wand into a mega indusrty, catering to a large export market. We saw how the tradition started to decline when pressure was exerted on it to grow and expand beyond its limits. Every handicraft tradition, every Indian art form these days, aims at an export market as the ultimate Mecca to prove its worth, forgetting the vast market that exists within the country itself. The British in the 19th and 20th centuries studied the requirements of the Indian populace because they were shrewd enough to realise the vast market demand which existed within the country. We are now in a confused state of globalisation, where foreign culture of the most debased kind is being imported while Indian traditional culture, even its *swamijis,* are being exported. In an attempt to make art global, foreign elements are inducted to make it acceptable to world market. In the process, the inherent value of the art form is totally destroyed. In this new frenzy to export, people forget that foreigners buy Indian art because it is Indian and not because it contains elements of an art that abounds in their own country.

India has a strong tradition in all her arts and crafts. We would indeed be poorer if we are unable to preserve this heritage and carry it forward, to make it meaningful for the present

generation. The Kamalkari heritage with its beautiful and vibrant colours, its eco-friendly nature, has a great potential as a vital component in the fashion trade (Plates 80, 81, 82 and 83). Proper design inputs would go a long way to present this craft in a modern setting, without losing its moorings in tradition (Plates 84, 85 and 86). In the 1990s, Kamaladevi Chattopadhyaya initiated the setting up of a Kalamkari training centre in Sri Kalahastri, and also aided cooperative societies in Masulipatnam for revival of the block-printed Kalamkari fabrics. She was able to revive interest in the craft with the help of a designer like Nellie Sethna, who put together the existing block prints in fresh layouts and colour combinations and which brought instant recognition for the art form. In present times, many old blocks in craftsmen's houses are being discarded and burnt as fuel. New blocks without a proper understanding of the nature of the craft are produced, and designs of poor artistic value have become common in Kalamkari textiles.

Unless there is proper understanding and concerted effort to revive the craft with proper inputs of technology and design, this heritage is in danger of being lost forever. Science and technology have opened up vast vistas of knowledge, strengthening traditional lore in many areas of arts and crafts.

There is now a revival of interest in organic methods, which support life. The world has woken up to the accumulation of poisonous wastes by man-made chemicals and right thinking people are trying to revive ancient practices, which taught men to live in harmony with Nature. It is in this context, that traditional crafts like Kalamkari need to be understood and promoted. The Kalamkari tradition based on vegetable dyes, and deeply rooted in Nature, has a message for the present generation.

Tradition is not static, but ever growing and changing, assuming new forms with each passing generation (Plate 86). Just like a piece of rock, broken from the hilllside, is weathered and shaped by the water of the mountain-river as it flows downhill, traditional art also gets shaped over centuries by the forces of an ever-changing culture. The inner core, however, remains the same.

In the Kalamkari heritage of India, the inner core of the art is deeply traditional and mystic in nature. Even an alien tradition, like the Iranian craft tradition, had brought with it, its own mysticism, which had shaped and strengthened this art further. Whether hand-printed or block-printed, the traditional designs and motifs of the Kalamkari craft speak a language of their own, and it is by recognising this inner voice that the future of the art can be secured.

Plate 85: Hand-painted Kalamkari table napkins (Kalakshetra).

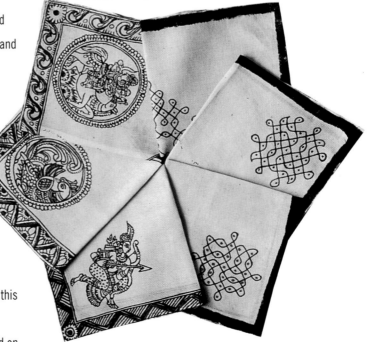

Plate 86: Kalamkari wall hanging.

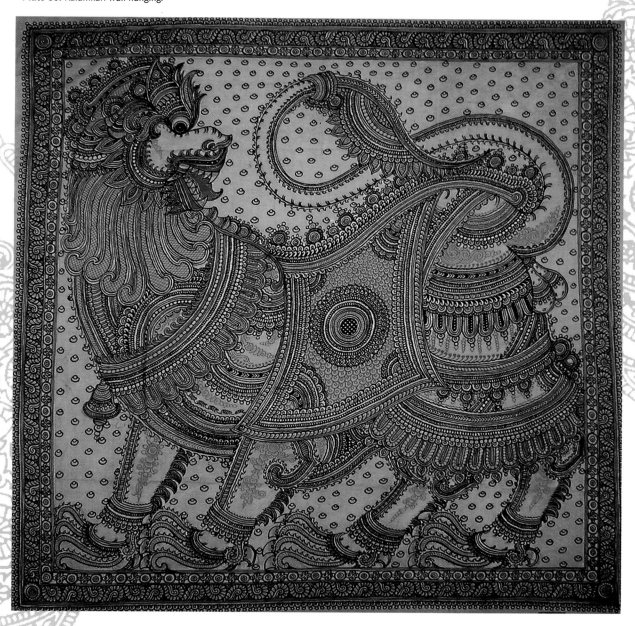

Glossary

Kurukshetra: Literally 'Land of the Kurus'. Region between Punjab and UP in North India, now a place of pilgrimage. In Indian mythology it was the battlefield where the Mahabharata war was fought

Kauravas: The hundred sons of King Dritharashtra, ruling king of the Kuru dynasty

Pandavas: Five sons of King Pandu, brother of Dritharashtra. Pandu died young and the Pandavas were harassed and driven out of their inheritance by their cousins, the Kauravas, and this culminated in the Mahabharata war

Guru: Teacher, preceptor

Dronacharya: Respected teacher of archery and martial arts in the court of King Dritharashtra. Both the Kaurava and Pandava princes were his students

Bhishma: Grand old sire of the Kuru dynasty venerated by both the warring factions in the epic *Mahabharata*

Sri Krishna: Prince of the Yadavas, who befriended the Pandavas and acted as charioteer to Arjuna in the Mahabharata war. He delivered the sermon of the *Gita* in the battlefield. Venerated as an incarnation of Lord Vishnu

Gita: A long treatise on the right code of conduct consisting of 700 verses expounded by Sri Krishna in the midst of the Mahabharata war. Quintessential religious text greatly venerated by all Hindus

Arjuna: Bravest among the Pandava princes. His skill in archery was central to the victory of the Pandavas in the battle at Kurukshetra

Chitrakatha: *Chitra* means 'picture' and *katha* means 'story'. Illustrated scrolls of mythological stories carried by folk minstrels

Shastras: Religious texts which lay down the code of conduct, duties and responsibilities of each person

Saivism: Hindu religious sect which upholds Lord Shiva as the Supreme God. Emphasises austerity as a means of salvation

Vaisnavism: Followers of Lord Vishnu asserting the supremacy of Lord Vishnu. Religious tradition with emphasis on devotion through love

Buddhism: Religion established around 6th century BC by Siddhartha Gautama, prince of Kapilavastu, who renounced his kingdom and became a monk. Known as the Buddha when he attained enlightenment. Established the Buddhist religion based on compassion and right conduct as opposed to Vedic orthodoxy

Jainism: Contemporaneous with Buddhism, the Jain religion was established by Mahavira. The sect gets its name from his title 'Jina' (conqueror), i.e. one who has conquered the senses

The *Mahabharata*: One of the longest epics in the world consisting of hundred thousand stanzas, the *Mahabharata*, attributed to the 4th century AD, was written by Sage Vyasa. It recounts the story of the gurus belonging to the lunar dynasty established by Bharata. Hence the title of the epic. The fight for the kingdom culminated in the battle of Kurukshetra. The Pandavas emerged victorious in spite of the greater might and numbers of the Kauravas. The battle of Kurukshetra is therefore often quoted as a parable to illustrate the victory of right over might

The *Ramayana*: Well-known Sanskrit epic written by Sage Valmiki recounts the story of Rama, scion of the solar dynasty, son of King Dasarath of Ayodhya. It is older to the *Mahabharata* and is attributed to the 3rd century BC

Tambura: Musical stringed instrument used as an accompaniment to vocal music

Vishnu Dharmottaram: Sanskrit treatise belonging to the 5th century AD, giving detailed instructions on various arts and crafts, especially painting

Tirthankara: Leaders of the Jain faith worshipped by their followers as emancipated souls

Sangitamandapam: Literally 'Hall of Music'. Special auditoriums built within temples and royal palaces for music and dance performances and other cultural activities

Dharma: Right behaviour. Correct code of conduct as laid down in the *Shastras*

Adharma: Unethical or wrong behaviour. Contrary to given code of conduct in the *Shastras*

Harikatha: Literally 'Story of Hari' or God. Religious stories rendered through music and mime by minstrels

Bhakti: Devotion to God

Vedas: Earliest religious texts of the Hindus attributed to 1400 BC. The word *veda* literally means 'knowledge' (from *vid* to 'know')

Bhagavata Purana: Epic poem recounting the story of Sri Krishna, who is worshipped as an incarnation of Lord Vishnu

Bija mantra: *Bija* means 'seed' and *'mantra'* is a 'magic word or syllable' (*man* is 'mind' and *tra* is 'to protect'). According to Hindu belief, God or any supernatural being is invoked through a specific 'seed word' or verse. The greatest and best known is the mystic syllable *'Om'*

Ashrama: Hermitage. Often denotes abode of sages who live in the forest

Avatara: Incarnation of God. In common parlance any change or metamorphosis is described as a new *avatara*

Brihat Samhita: Social and cultural history written by Varahamihira, during the closing years of Gupta rule in AD 505

Sattva, rajas and *tamas*: Description of the three mental states latent in human beings known as *gunas*. *Sattva* denotes an exalted spiritual state of being or equilibrium; *rajas* is activity, a mental state denoting passion and restlessness; *tamas* is the lowest among the three, denoting inertia or dullness

Yagna: From the root word *yaj,* it means 'to worship'. Performance of prescribed Vedic rituals with the aid of the sacrificial fire

Aswamedha yagna: Sacrifice performed by kings to establish their suzerainty. In this *yagna*, a horse, duly anointed after rituals, is let loose to roam beyond the boundaries of the kingdom and rulers or chieftains of the regions, through which it goes, acknowledge their fealty and friendship to the king by allowing it free passage

Arthashastra: Exhaustive Sanskrit treatise on social history and politics written by Kautilya, chief minister of Chandragupta Maurya, 321 BC

Kali: One of the aspects of Goddess Parvati, wife of Shiva, in her aspect as a dark avenging goddess, fearful to sinners

Putrakameshti yagna: Sacrifice performed to beget sons when the king does not have progeny

Asokavan: Forest in the kingdom of Lanka where Sita was kept captive by the demon Ravana

Ganesa: Son of Lord Shiva and Parvati. Divine figure with elephant face is considered God of Success and remover of obstacles and therefore worshipped at the beginning of any project

Kaliya mardanam: Vanquishing of the dreaded snake, *Kaliya*, by Sri Krishna. Part of the story describing the miracles performed by Sri Krishna as a child in the *Bhagavatam*

Hanuman: Valorous monkey-God. Follower and great devotee of Sri Rama who helps to seek and rescue Sita from the evil Ravana

Rishyasringa: Hermit, son-in-law of King Lomapada. Acted as chief priest in the sacrifice performed by King Dasarath in the *Ramayana*. He is said to have been born of Rishi Vibhandaka and a doe and hence has a horn on his head

Asuras: Demons. Enemies of the celestial *suras* or gods

Ahimsa: Non-violence

Payasam: Sweet milk preparation used in religious rituals as sacramental offering which is partaken to receive Divine blessing

Kabanda: Grotesque monster with mouth in the belly and long arms with which it captures people to eat. Actually a celestial, cursed by a *rishi* for his insatiable appetite, Kabanda is released from the curse when killed by Rama

Some Museums and Private Collectors of Indian Textiles

INDIA

- Jagdish and Kamla Mittal Museum, 1-2-214 Gagan Mahal Road, Hyderabad, Andhra Pradesh; Salar Jung Museum, Divan Devdu Palace, Hyderabad, Andhra Pradesh.
- Birla Academy of Art & Culture Museum, 108-109, Southern Avenue, Calcutta; Museum and Art Gallery, Ramakrishna Mission Institute of Culture, Golpark, Calcutta; Indian Museum, 27, Jawaharlal Nehru Road, Calcutta-13, West Bengal.
- The Kutch Museum, Mahadev Gate, Bhuj, Kutch, Gujarat; Madansinhji Museum, The Palace, Bhuj; Textiles & Art of the People of India, Garden Silk Mills Complex, Sahara Gate, Surat, Gujarat; Museum and Picture Gallery, Sayaji Park, Vadodara-390022, Gujarat; Calico Museum of Textiles, Retreat, Shahi Bagh, Ahmedabad, Gujarat; Shreyas Folk Museum of Gujarat, Shreyas Hill, Ahmedabad, Gujarat.
- Raja Dinkar Kelkar Museum, 1378 Shukrawar Peth, Natu Baug, Pune-411002, Maharashtra; Prince of Wales Museum, M.G. Road, Fort, Bombay.
- National Museum, Janpath, New Delhi; National Handicrafts and Handloom Museum, Pragati Maidan, Bhairon Road, New Delhi.
- Orissa State Museum, Bhubaneswar, Orissa
- K. Sreenivasan Art Gallery & Textile Museum, Kasturi Sreenivasan Trust, Cultural Centre, Avanashi Road, Coimbatore, Tamil Nadu; Government Museum, Pantheon Road, Chennai, Tamil Nadu; Royal Palace Museum, Palace Complex, Thanjavur, Tamil Nadu.
- Bharat Kala Bhavan, Benaras Hindu University, Varanasi, Uttar Pradesh.

OVERSEAS

BELGIUM
- Musees Royaux d'Art et d'Historie, 10 Parc du Cinquantenaire, 1040 Brussels.

BANGKOK
- The National Museum, Bangkok.

CANADA
- Royal Ontario Museum, 100 Queens Park, Toronto, Ontario M55 2C6.

FRANCE
- Musee Guimet, 6 Place d'Iena, 75116, Paris.
- Bibliotheque Nationale, Fonds, Francais.
- Musee des Arts Decoratifs, Pavillon de Marsan, 107-109 Rue de Rivoli, 75001 Paris.

JAPAN
- Museum of Textiles, 5-102 Tomobuchi-cho, 1-Chome, Miyakojima-ku, Osaka.

UNITED KINGDOM
- British Museum, Department of Oriental Antiquities, Great Russell Street, London WC1B 3DC.
- Victoria and Albert Museum, Cromwell Road, South Kensington, London SW7 2RL.
- Ashmolean Museum, Beaumont Street, Oxford OX1 2PH.

UNITED STATES
- Museum of Fine Arts, 465 Huntington Avenue, Boston, MA.
- Cooper Hewitt Museum of Design, Smithsonian Institution, 5th Avenue at 91st Street, New York City, New York.
- Art Institute of Chicago, Michigan Avenue, Adams Street, Chicago, IL.
- Textile Museum, 2320 S. Street MW, Washington DC.

Bibliography

1. G.P. Baker: *Calico Painting and Printing in the East Indies in the XVII and XVIII Centuries*

2. Devi Lal Samar (Bharatiya Lok Kala Mandal): *Folk Entertainments of Rajasthan*

3. W.S. Hadaway: *Cotton Painting and Printing in the Madras Presidency*

4. Mulk Raj Anand: *Madhubani Painting*

5. B. Mohanty: *Pata Paintings of Orissa*

6. Edgar Thurston: *Monograph on the Cotton Fabric Industry of Madras Presidency,*

7. Ananda K. Coomaraswamy: *The Arts and Crafts of India and Ceylon*

8. Cambridge *History of India*

9. V. Raghavan: *The Indian Heritage*

10. Sisir Kumar Mitra: *The Vision of India*

11. Radha Kumud Mookerji: *Glimpses of Ancient India*

12. H. Zimmer: *Myths and Symbols in Indian Art*

13. E.B. Havell (selections from the records of Fort St. George, 1885-1886): *Arts and Industries*

14. Cooper, Ilay and John Gillow: *Arts and Crafts of India, 1998*

15. (Dr) M.R. Pal: *Historical and Social Perspective on Handicrafts*

16. Bharatiya Vidya Bhavan: *The History and Culture of the Indian People: The Vedic Age*

17. L.N. Rangarajan: Kautilya: *The Arthasastra*

18. Ajay Mitra Sastri: *India as Seen in the Brhatsamhita of Varahamihira*

19. J.M. Somasundaram Pillai: *A History of Tamil Literature*

20. P.T. Srinivasa Iyengar: *History of the Tamils*

21. Wilfred H. Schoff: *Periplus of the Erythrean Sea: Trade in the Indian Ocean*

22. E.H. Warmington: *Commerce between the Roman Empire and India*

23. (Dr) Forbes Watson: *Survey of the Costumes and Textile Manufactures of India*